Sleep is better than medicine
(English proverb)

Sleeping and Dreaming

DEUTSCHES
HYGIENE-MUSEUM
DRESDEN

black dog
publishing

wellcome
collection

Essays

The Sleeper
Nils Klinger
2003

Photograph:
Property of the artist

View from the side XVII.

Quotes and Excerpts

Selected by Hugh Aldersey-Williams

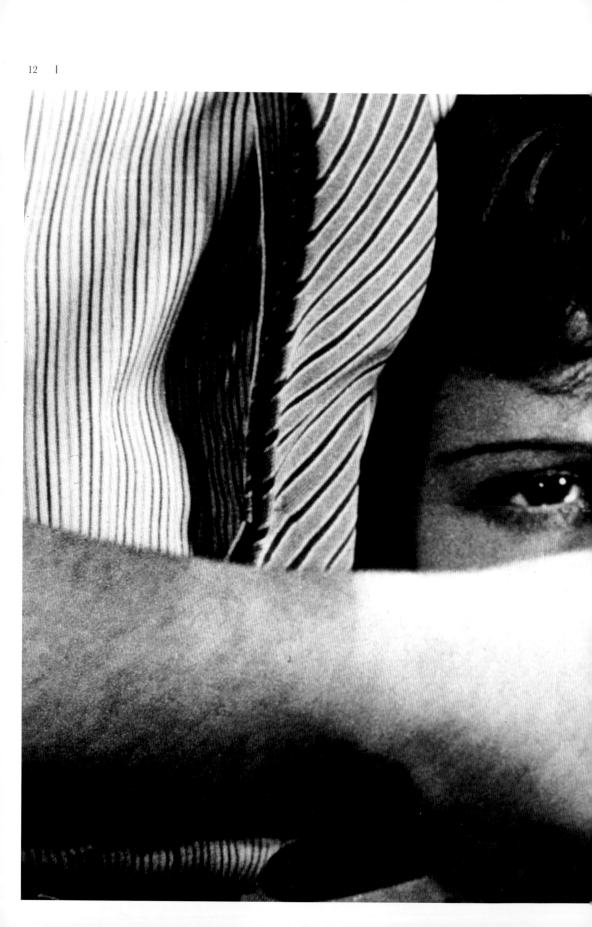

Still from the film
Un Chien Andalou
Direction and production:
Luis Buñuel
Script: Luis Buñuel in
collaboration with Salvador Dalí
Camera: Albert Duverger
1929

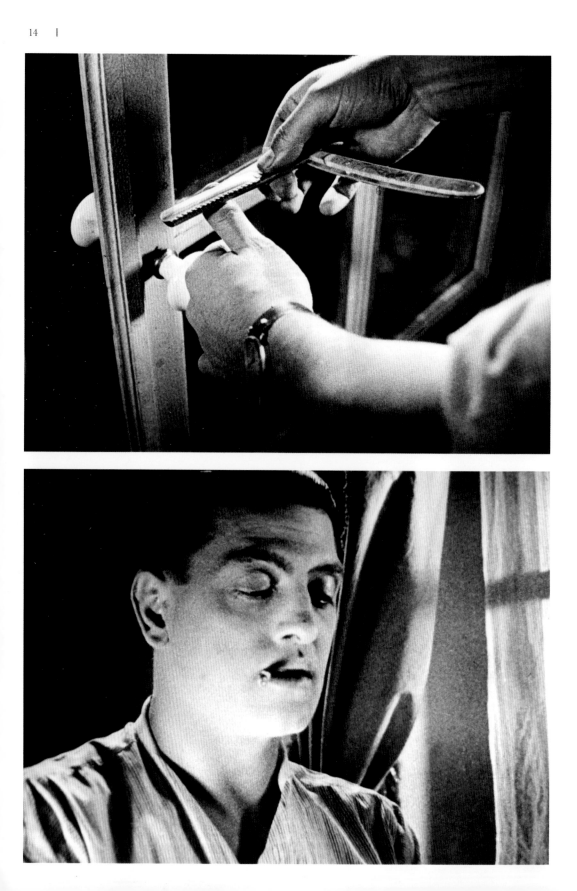

Stills from the film
Un Chien Andalou
Direction and production:
Luis Buñuel
Script: Luis Buñuel in collaboration
with Salvador Dalí
Camera: Albert Duverger
1929

16 minutes
Paris, Les Grands Films Classiques

Luis Buñuel and Salvador Dalí
based their film *Un Chien Andalou* on
two dreams. Buñuel dreamt how a
large cloud severed the moon and a
razor blade had slit open an eye;
Dalí had seen a hand full of ants in a
dream. The overriding idea was
"to open all doors to the irrational",
to let the film follow nothing but the
logic of the dream and to avoid any
real and time-bound reference.
With *Un Chien Andalou* Buñuel
and Dalí initiated the surrealist
film movement.

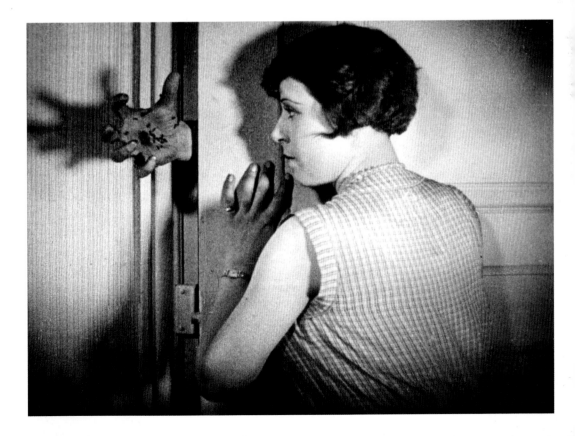

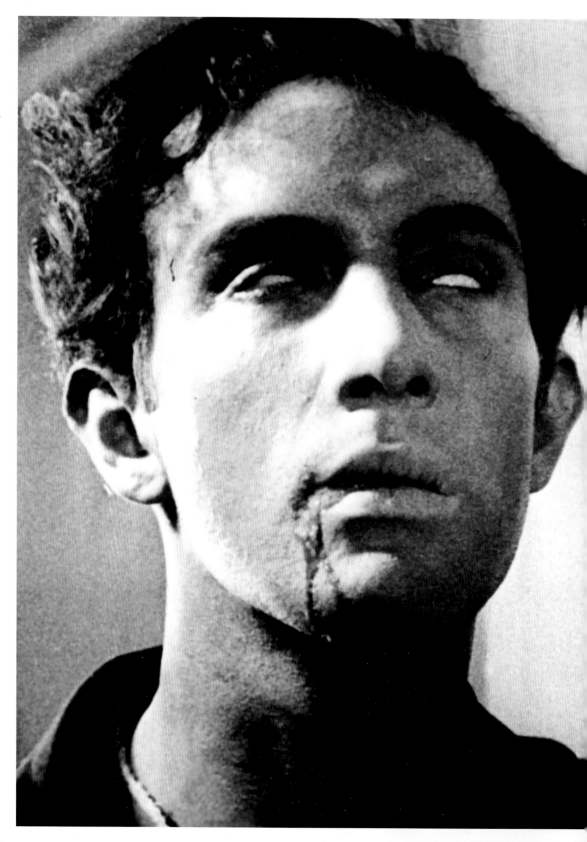

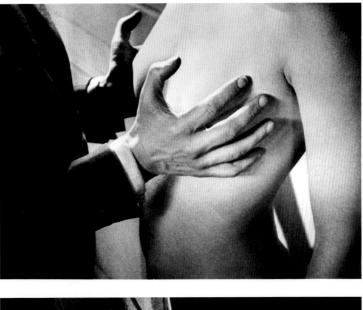

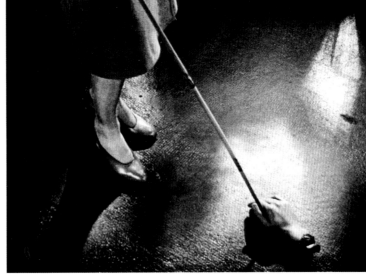

Detail from
Untitled
Beate Frommelt
2006

Introduction

Ken Arnold, Klaus Vogel

With so much of our time devoted to sleeping and dreaming, it is maybe not surprising that artists, writers and poets; scientists, doctors and philosophers, have all endlessly applied themselves to the exploration of this fascinating, yet also enigmatically dark side of human existence.

Since antiquity, the idea has existed that when we sleep we are dead to the world, with the likes of Ovid and Cicero long ago identifying death the older brother of sleep. Like death, our sleep is not subject to our creative will; our dreams are unalterable and inescapable. Sleep and death both give us a sense of helplessness—a lack of control. But the analogy between sleep and death also tempers death's cruelty. If we are lucky, when our time comes, we might slip unconsciously from one to the other. Little wonder then that sleep has long had a low standing among those who want, or seem to be, successful: for them, sleep is just a waste of time. Plato urged that sleep be reduced to a minimum to prevent it from unnecessarily obstructing the work of the mind, and the thinkers of the enlightenment advocated the same idea. Yet people sleep and dream "whether they want to or not" (Diderot).

Like sleep, dreaming too is a compulsion, and we are offered up to its whim every night as we drift off into unconsciousness. As Ralf Konersmann reminds us in his essay, it was Descartes who wanted to break the power of the dream. He believed it should remain separate and segregated from waking, along with the dreamlike reality it imposes. From the middle of the nineteenth century, our attitudes towards dreams changed radically. A new artistic sensibility emerged with an acute interest in that which had been rejected for so long: the arbitrary power of the dream, its foreign logic, and its specific mechanisms. In their own terms—in the field of art—Odilon Redon and Max Klinger prefigured the work of Freud.

Lord Byron

from *Don Juan*

Death, so called, is a thing which makes men weep,
And yet a third of life is passed in sleep.

For Freud, dream interpretation was the royal road "to the knowledge of the unconscious in mental life", and the majority of psychoanalysts today continue to assume that dream analysis is crucial for both the patient and the analyst, although its importance in the present-day therapeutic context has diminished. It has remained the abiding principle of psychoanalysis that dream interpretation is based on the associations and entire clinical context of the individual patient, and that it holds meaning solely on this basis. Dream interpretation was born in the early twentieth century; with it, the bourgeoisie sought to plumb the depths of its soul. Psychological research today also has at its disposal diagnosis and therapy derived from the findings of neuroscience and sleep research. All of these lines of investigation deal with the interactions shaping the relationship between dreams and sleep.

Following the catastrophes of the twentieth century, dream research was joined by trauma research. As the work of the Sigmund Freud Institute in Frankfurt has shown, this research deals with the severe lesions suffered by the mind that permanently hinder therapeutic intervention. Traumatic experiences may produce lifelong nightmares and, if not treated, leave traces on the brain that can change a person's behaviour forever. Only in recent years has the field of neurobiology begun to understand such complexities.

The South African neurologist and psychoanalyst, Mark Solms, uses neuroscientific methods to find the places in the brain where dreams arise. And, as he explains in his contribution to this book, the inner regions of the brain, which are responsible for our instincts, produce dreams, while its outer regions—its logical, 'civilised' parts—are switched off. So that in dreams, our brain, as it were, "turns itself inside out". Through Solm's neurobiological research, the teachings of Freud gain renewed meaning.

Today we also know that sleep is more than just a temporal bridge, a state of unconsciousness between waking states. Sleep research from the fields of neurobiology and psychology shows sleep to be a highly active state accompanied by different physiological reactions. The research separates sleep into five phases, among which the so-called REM sleep stage stands out in stark contrast to the others. REM sleep was long considered to be the only dream phase—an idea that scientists like Solms have now disproven. The fact that human beings dream in different ways in deep sleep and REM is of great importance to all manner of investigation into the brain. But one result from the modern sleep research in particular has redeemed the reputation of sleep: the finding that learning while sleeping is possible. This is true

only, however, in the sense that memory contents absorbed immediately
before falling asleep are consolidated during sleep. People who do not
sleep enough perform worse, age faster and die younger.

These new findings on the interactions between sleep and dreams, along
with enduringly big questions about why we sleep and dream at all (what
we actually know about this peculiar state in scientific, social and cultural
terms) as well as how modern society is coping in a 'world without sleep'
are cumulatively the subjects of both this book and of the exhibition it
accompanies. And as always, art has the last word: as Kafka knew, writers
dream without sleeping. This is how they invent the worlds of their novels
and artistic utopias. A L Kennedy's contribution within these covers
describes how it works for her, how being a writer necessitates living parts
of life in a waking dream world of your own making.

The *Sleeping and Dreaming* project is based on a collaboration between
Wellcome Collection and the Deutsches Hygiene-Museum Foundation,
and both institutions would like to thank all those individuals who have
helped to make this book and exhibition possible. We can only name a few
individuals here: first and foremost, the curator of the exhibition, Michael
Dorrmann; and his team at the Deutsches Hygiene Museum—Frank
Schumann, Sigrid Walther-Goltzsche and Saskia Weiss. Significant
contributions have also been made by Kate Forde, James Peto and Lucy
Shanahan of the Wellcome Collection and we are grateful too for the help
and advice of the artist Susan Hiller.

We would like to express our sincere thanks to all the authors of the book
for their contributions, and especially to Helga Raulff for her work on the
commissioning of essays; to Hugh Aldersey-Williams for the selection of
the additional texts and quotations and to Nadine Monem of Black Dog
Publishing for all her work on the editing and production of the book.

We wish you a good night's sleep, and pleasant dreams.

Fyodor Dostoevsky

from *The Dream of a Ridiculous Man*
(trans Constance Garnett)

Dreams, as we all know, are very queer things: some parts are presented with appalling vividness, with details worked up with the elaborate finish of jewellery, while others one gallops through, as it were, without noticing them at all, as, for instance, through space and time. Dreams seem to be spurred on not by reason but by desire, not by the head but by the heart, and yet what complicated tricks my reason has played sometimes in dreams, what utterly incomprehensible things happen to it! My brother died five years ago, for instance. I sometimes dream of him; he takes part in my affairs, we are very much interested, and yet all through my dream I quite know and remember that my brother is dead and buried. How is it that I am not surprised that, though he is dead, he is here beside me and working with me? Why is it that my reason fully accepts it? But enough. I will begin about my dream. Yes, I dreamt a dream, my dream of the third of November. They tease me now, telling me it was only a dream. But does it matter whether it was a dream or reality, if the dream made known to me the truth? If once one has recognised the truth and seen it, you know that it is the truth and that there is no other and there cannot be, whether you are asleep or awake. Let it be a dream, so be it, but that real life of which you make so much I had meant to extinguish by suicide, and my dream, my dream—oh, it revealed to me a different life, renewed, grand and full of power!

Listen.

I have mentioned that I dropped asleep unawares and even seemed to be still reflecting on the same subjects. I suddenly dreamt that I picked up the revolver and aimed it straight at my heart—my heart, and not my head; and I had determined beforehand to fire at my head, at my right temple. After aiming at my chest I waited a second or two, and suddenly my candle, my table, and the wall in front of me began moving and heaving. I made haste to pull the trigger.

In dreams you sometimes fall from a height, or are stabbed, or beaten, but you never feel pain unless, perhaps, you really bruise yourself against the bedstead, then you feel pain and almost always wake up from it. It was the same in my dream. I did not feel any pain, but it seemed as though with my shot everything within me was shaken and everything was suddenly dimmed, and it grew horribly black around me. I seemed to be blinded, and it benumbed, and I was lying on something hard, stretched on my back; I saw nothing, and could not make the slightest movement. People were walking and shouting around me, the captain bawled, the landlady shrieked—and suddenly another break and I was being carried in a closed coffin. And I felt how the coffin was shaking and reflected upon it, and for the first time the idea struck me that I was dead, utterly dead, I knew it and had no doubt of it, I could neither see nor move and yet I was feeling and reflecting. But I was soon reconciled to the position, and as one usually does in a dream, accepted the facts without disputing them.

And now I was buried in the earth. They all went away, I was left alone, utterly alone. I did not move. Whenever before I had imagined being buried the one sensation I associated with the grave was that of damp and cold. So now I felt that I was very cold, especially the tips of my toes, but I felt nothing else.

I lay still, strange to say I expected nothing, accepting without dispute that a dead man had nothing to expect. But it was damp. I don't know how long a time passed—whether an hour or several days, or many days. But all at once a drop of water fell on my closed left eye, making its way through the coffin lid; it was followed a minute later by a second, then a minute later by a third—and so on, regularly every minute. There was a sudden glow of profound indignation in my heart, and I suddenly felt in it a pang of physical pain. "That's my wound", I thought; "that's the bullet…". And drop after drop every minute kept falling on my closed eyelid. And all at once, not with my voice, but with my entire being, I called upon the power that was responsible for all that was happening to me:

"Whoever you may be, if you exist, and if anything more rational that what is happening here is possible, suffer it to be here now. But if you are revenging yourself upon me for my senseless suicide by the hideousness and absurdity of this subsequent existence, then let me tell you that no torture could ever equal the contempt which I shall go on dumbly feeling, though my martyrdom may last a million years!"

I made this appeal and held my peace. There was a full minute of unbroken silence and again another drop fell, but I knew with infinite unshakable certainty that everything would change immediately.

qui ne dependent ordinairement d'aucune idée; ie dis
ordinairement, car ils en peuuent quelquefois auffi de-
pendre.

Maintenant que ie penfe auoir fuffifamment expliqué
toutes les fonctions de la veille, il ne me refte que fort
peu de chofes à vous dire touchant *le fommeil;* car pre-
mierement il ne faut que ietter les yeux fur cette 50. fi-
gure, & voir comment les petits filets D, D, qui fe vont
rendre dans les nerfs y font lafches & preffez, pour en-
tendre comment, lors que cette Machine reprefente le
corps d'vn homme qui dort, les actions des objets ex-

N iij.

*CI.
Du fom-
meil ; & en
quoy il dif-
fere de la
veille.*

**Representation of the
Sleeping Brain**
in: René Descartes: *L'Homme et un
Traité de la Fonction du Fœtus.*
Paris, 1664 p.101

Woodcut
Dresden, Sächsische
Landesbibliothek
Staats und Universitätsbibliothek

Switching on—switching off: In his
work *L'Homme* (Man) René Descartes
gave a mechanical explanation for
the difference between wakefulness
and sleep: While sleeping, the link
between the brain and the outside
world is interrupted by a contraction
of the nerve tracts. Therefore man
can neither feel any sensations nor
move his extremities.

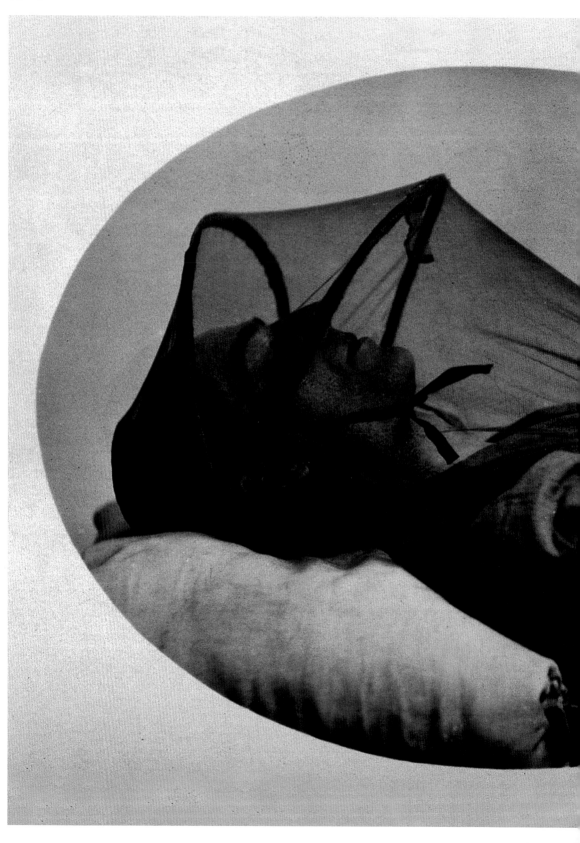

c 1910

Postcard
Wellcome Library, London

Detail from
Nathaniel Kleitman
and Bruce Richardson's
Cave Experiment

Without Sleeping, There is No Waking:

an Introduction to Sleep in Modern Society

Jürgen Zulley

Human beings sleep away almost one third of their lives, but this time is not wasted, on the contrary, sleep is essential and without it we would soon perish — indeed experiments show that animals die when altogether prevented from sleeping. Outwardly, sleep is easy to describe since the sleeper is in repose, usually in a relaxed, recumbent position with reduced—but not altogether absent—perception. When sleeping, we merely apprehend less: our consciousness is altered but still active, and clearly structured processes of renewal and learning still take place. All living beings undergo systematic fluctuations in the majority of their functions throughout the day and night, experiencing a 'slump' between three and four o'clock in the morning during which perceptions are distorted, time awareness and state of mind are altered, and physical misperceptions may arise. The body reacts to physical probes in drastically different ways based on the time of day, for example the same pain stimulus is perceived as being three times more intense in the morning as it is in the afternoon, and medications have entirely different effects depending on the time of day they are administered. Analgesics, for example, are significantly more effective in the evening than in the morning and the 'maximal tolerable dose' for chemotherapy is four times as high if it is administered at the right time of day, significantly improving the efficiency of treatment.[1]

Lawrence Sterne

from *Tristram Shandy*

Now my father... was musing within himself about the hardships of matrimony, as my mother broke silence.—

—"My brother Toby", quoth she, "is going to be married to Mrs Wadman".

—"Then he will never", quoth my father, "be able to lie diagonally in his bed again as long as he lives".

Igor Stravinsky

Dreams are my psychological digestive system

Not only does an energy slump occur during the night; a slightly milder one is seen between one and two o'clock in the afternoon as well. Energy peaks, on the other hand, occur between ten and eleven o'clock in the morning and between four and five o'clock in the afternoon. In the morning and in the evening, our blood pressure is at its highest, dropping considerably between these two intervals. These everyday periodic changes—along with seasonal and circadian fluctuations—characterise sleeping and waking behaviour, as they do psychological variables such as subjective alertness and productivity, and physiological variables such as body temperature and circulatory instability. These changes are the result of biological rhythms: endogenous temporal programmes within the organism that follow 12-hour cycles alongside the dominant circadian 24-hour cycles. Regular but less pronounced ultradian (90 minute) fluctuations occur in four-hour cycles as well. In the research, these results have been interpreted to suggest that the human organism is subject to a number of hierarchically ordered, periodic biological processes.[2]

The Biological Clock

These lines of enquiry are addressed by the discipline of chronobiology, which examines the phenomena underlying biological rhythms and the mechanisms by which they can be influenced. Research in this field aims to produce evidence enabling conclusions about fluctuations in these rhythms and about their treatment. One of the first important results of chronobiological research was the finding that biological rhythms originate in, and are governed by, 'internal clocks'. The groundwork for this hypothesis was laid by Jurgen Aschoff's experiments in temporal isolation conducted in the early 1960s at the Max Planck Institute for Behavioural Physiology in Andechs.[3] The test subjects lived in a subterranean test room in complete isolation from the outside world—of their own free will, of course—for four weeks, and were thus able to follow their own spontaneous 'inner' endogenous rhythms. All of the functions measured—such as body temperature and productivity but also sleeping and waking—continued to occur quite regularly. The rhythm itself, however, no longer followed a 24-hour cycle as in everyday life but a 25-hour cycle, diverging from the rhythm of the outside world by one hour. This periodicity is referred to as the 'circadian rhythm' (meaning approximately one day). The results of this study have led to the conclusion that internal 'biological clocks' govern our rhythms and thus determine when we feel tired

and when we feel alert. But since the internal clock does not run on an exact 24-hour cycle, it has to be synchronised with the workings of human society through particular stimuli. In the mid-1980s it was found that daylight acts as our most important internal 'timer' mechanism: its brightness must be at least 2,500 lux to be effective but its spectrum does not play a decisive role. Thus, the regular daily light stimulus brings our endogenously driven circadian rhythms into alignment with the rhythm of day and night.

Contrary to outward appearances, sleep is a highly active process, even though it takes place in an altered state of consciousness and activity. Sleep is not a monotonic phenomenon but changes constantly following a characteristic pattern. As a rule, sleep onset is preceded by a relaxed waking state. As we fall asleep, motor activity generally decreases and intentional motor activity stops completely, with the sleeper reacting to external stimuli in only limited ways. In contrast to the comatose state, sleep can be interrupted or stopped at any time with the appropriate triggers. It is embedded in the circadian rhythm described above, which prescribes nighttime as the optimal period for sleep. In this period, the trophotropic (regenerative) functions work at a maximum (digestion, hormone secretions), while the opposing, ergotropic (productive) functions are significantly reduced. Herein may lie one of the functions of sleep: it bridges a time span characterised by instability and functional inefficiency of the different organ systems, a period that cannot be used for interaction with the environment but that can be utilised for functions incompatible with motor activity. During the night, both the external conditions (such as darkness and cold) and the internal conditions determined by biological rhythms (low energy, circulatory instability and fatigue) are favourable to reducing outwardly oriented activities and providing for vital revitalisation and regeneration.

Sleep itself, however, is a highly active, variable process. The variations are most clearly expressed in the high degree of neuronal activation, raising the question of whether sleep can even be considered a homogenous process at all. The sleep cycle is divided into five stages corresponding to polysomnographic registration using electroencephalogram (EEG), electromyogram (EMG) and electrooculogram (EOG) methods of investigation. Sleep stages one to four are distinguished according to their EEG patterns and are known as non-REM sleep (NREM). Sleep stages three and four are referred to as deep or delta sleep and are characterised by a low degree of physical response in the sleeper, making he or she difficult to wake up. The fifth stage is known as REM sleep and is marked by rapid eye movements and a complete relaxation of the postural muscles, in part caused by an incapacity to move. However quiet the body, central nervous system activity during this stage (as registered in the EEG) indicates a psychic state akin to waking. In the REM stage, an increased phasic activation of different functions occurs, occasionally with an increased frequency of respiration and

heartbeat.[4] REM sleep differs so dramatically from NREM sleep that a distinction between sleeping and waking appears too crude, and a differentiation into three stages—REM, NREM and waking—seems more appropriate. A healthy sleeper spends 55–60 per cent of total sleep time in sleep stages one and two, 15–25 per cent in stages three and four, and 20–25 per cent in REM sleep.[5]

The Dream

Mentation processes are underway in consciousness throughout all sleep stages, however people report the contents of consciousness after waking up with differing frequency depending on the sleep stage during which they were aroused. This suggests that consciousness is active throughout all of sleep, but with various intensities and qualities dependant on the sleep stage. REM is considered to be the central dream stage, with over 80 per cent of those awakened during this phase reliably reporting vivid dreams. Recent experiments, however, have challenged REM's accepted position as dream stage, showing that dreamlike—but much more realistic—conscious content can be recalled from other sleep stages, albeit less frequently. The processes underway in consciousness change during sleep: in REM sleep they are less realistic and more hallucinatory, while memories reported from the other sleep stages more closely resemble everyday thoughts and experiences. There is little doubt that dream reports do indeed draw on the mental activities actually experienced during sleep. The degree of visual, motor and general activation is correlated to the intensity of the dream events. In REM sleep, sensory information is produced within the brain stem through internal activation rather than the external stimuli that provide the normal triggers in waking life. These signals stimulate the sensory channels in the cortex and

Daniil Kharms

"Sleep Teases a Man", from *Incidences*
(trans Neil Cornwell)

Markov took off his boots and, with a deep breath, lay down on the divan.

He felt sleepy but, as soon as he closed his eyes, the desire for sleep immediately passed. Markov opened his eyes and stretched out his hand for a book. But sleep again came over him and, not even reaching the book, Markov lay down and once more closed his eyes. But, the moment his eyes closed, sleepiness left him again and his consciousness became so clear that Markov could solve in his head algebraical problems involving equations with two unknown quantities.

Markov was tormented for quite some time, not knowing what to do: should he sleep or should he liven himself up? Finally, exhausted and thoroughly sick of himself and his room, Markov put on his coat and hat, took his walking cane and went out on to the street. The fresh breeze calmed Makarov down, he became rather more at one with himself and felt like going back home to his room.

Upon going into his room, he experienced an agreeable bodily fatigue and felt like sleeping. But, as soon as he lay down on the divan and closed his eyes, his sleepiness instantly evaporated.

In a fury, Markov jumped up from his divan and, hatless and coatless, raced off in the direction of Tavrichesky Park.

release different memories that are associatively connected to one another and evoke bizarre images and processes referred to as dreams.[6] Upon waking from NREM sleep, the more realistic dreams can be confused with everyday thoughts. The contents of dreams deal almost exclusively with visual stimuli, while taste, smell and pain are virtually never experienced in dreams.

While cognitive events that take place during REM sleep are the most accessible to the sleeper, more recent studies using imaging techniques confirm that dreaming, and thus cognitive activity, takes place throughout virtually all of sleep.[7] It has also been shown that activities carried out during the day appear again in dreams, with an overwhelming focus on physically dynamic activities rather than passive intellectual actions like reading or writing. This can be seen as a contradiction of Freud's thesis that the dream has a compensatory effect for the lack of desire fulfillment in waking life. This could suggest that themes with an emotional importance tend to repeat themselves in dreams.

Dream-like memories can occur during the so-called hypnologic phases of falling asleep, waking or returning to sleep. Three types of altered consciousness can be identified in this context: discontinuations of structured thought processes; changes in bodily schema (that is, in the perception of one's own body) and the appearance of usually optical hallucinations (hypnagogic hallucinations). Hypnagogic dream reports are short and fragmentary, while dreams that occur later in the sleep onset phase are often almost impossible to distinguish from dreams during REM sleep.[8] The wide variation in reports from sleepers aroused at different sleep stages provides further evidence that the conscious processes persist through every phase of sleep in one form or another.

Sleep Rhythms

Sleep itself displays a rhythmic structure, following 90-minute cycles known as ultradian rhythms. Sleep starts in stage one, proceeds through stages two to

The Bible

Genesis, 28:10

And Jacob went out from Beersheba, and went toward Haran.

And he lighted upon a certain place, and tarried there all night, because the sun was set; and he took of the stones of that place, and put them for his pillows, and lay down in that place to sleep.

And he dreamed, and behold a ladder set up on the earth, and the top of it reached to heaven: and behold the angles of God ascending and descending on it.

from The Song of Solomon

I sleep, but my heart waketh: it is the voice of my beloved that knocketh, saying, open to me, my sister, my love, my dove, my undefiled: for my head is filled with dew, and my locks with the drops of the night.

Dr Seuss

from *Dr Seuss' Sleep Book*

Now the news has arrived
From the valley of Vail
That a Chippendale Mupp has just bitten his tail,
Which he does every night before shutting his eyes.
Such nipping sounds silly. But, really, it's wise.
He has no alarm clock. So this is the way
He makes sure that he'll wake at the right time of day.
His tail is so long, he won't feel any pain
'Til the nip makes the trip and gets up to his brain.
In exactly eight hours, the Chippendale Mupp
Will, at last, feel the bite and yell 'Ouch!' and wake up.

four, and then ends in the first REM phase. The first cycle contains a relatively large amount of deep sleep and little REM sleep. The amount of deep sleep decreases across the course of the night, with the length of REM sleep increasing. Arousals and awakenings occur relatively frequently during the night, especially in the REM phases and in the second half of nocturnal sleep. A number of studies have shown an average of four arousals from sleep per hour throughout the night, and thus a total of 28 brief arousals within seven hours of sleep.[9] Whether or not one remembers these the following morning depends on how much time was spent awake—more precisely—for a waking phase to be remembered it must be at least three minutes long. Nocturnal waking phases of less than three minutes are often forgotten and longer waking phases are remembered the next morning. The same is true for the memory of dreams.

The number of hours an adult sleeps varies widely and generally lies between five and ten hours. For Great Britain, the average is around seven hours. The 'average Briton' sleeps from 11:12 pm to 6:53 am.[10] 'Long sleepers' sleep more than nine and a half hours, while 'short sleepers' feel well-rested after less than six and a half hours. However revitalised they might feel, recent studies suggest that both short and long sleepers display an increased risk of morbidity and mortality.[11] The length of time we spend sleeping changes with age. While newborns sleep as much as 16 hours, older people can reduce their nocturnal sleeping to five hours or less but then take more frequent naps during the day.

This change is caused by a flattening off and compression of the circadian periods with increasing age, leading older people to experience less deep sleep and more frequent sleep disruptions. Other factors that affect the length of time we sleep include gender (women sleep longer than men) and seasonal conditions, with the average person sleeping longer in winter than in the summer. Genetic factors might also play a part in individual sleep duration.

One component of our physiological sleeping/waking behaviour is what is known as the midday slump. Between one and two o'clock in the afternoon, many active bodily functions drop to a level close to that found in sleep. In this period, we experience an increased need for sleep. Afternoon naps correspond to our biological programme and bridge a period that is unsuitable for activities involving performance demands. Following an afternoon nap, our productive capacities and state of mind are improved. The optimal length of an afternoon nap is ten to 30 minutes. Since daytime sleep can reduce nocturnal sleep needs, patients with insomnia are recommended to keep midday naps as short as possible.

The Effects of Fatigue and Sleep Disorders

Sleep disorders and the negative consequences of fatigue due to lack of sleep are widely underestimated. The Chernobyl nuclear reactor catastrophe was mainly the result of errors by maintenance personnel after they had worked until the early hours of the morning. The Exxon Valdez tanker disaster occurred after an exhausted crew had spent an extensive period of time carrying out bunker work during the night. The dangerous

Emily Brontë

from *Wuthering Heights*

(Cathy, awakened by a tree branch scraping against her window in the wind, falls asleep again and dreams)

This time, I remembered I was lying in the oak closet, and I heard distinctly the gusty wind, and the driving of the snow; I head, also, the fir-bough repeat its teasing sound, and ascribed to it the right cause; but it annoyed me so much, that I resolved to silence it, if possible; and, I thought, I rose and endeavoured to unclasp the casement. The hook was soldered into the staple: a circumstance observed by me when awake, but forgotten. "I must stop it, nevertheless!" I muttered, knocking my knuckles through the glass, and stretching an arm out to seize the importunate branch; instead of which, my fingers closed on the fingers of a little, ice-cold hand! The intense horror of nightmare came over me: I tried to draw back my arm, but the hand clung to it, and a most melancholy voice sobbed, "Let me in—let me in!" "Who are you?" I asked, struggling, meanwhile, to disengage myself. "Catherine Linton", it replied, shiveringly (why did I think of Linton? I had read Earnshaw 20 times for Linton). "I'm come home: I'd lost my way on the moor!" As it spoke, I discerned, obscurely, a child's face looking through the window. Terror made me cruel; and, finding it useless to attempt shaking the creature off, I pulled its wrist onto the broken pane, and rubbed it to and fro till the blood ran down and soaked the bedclothes: still it wailed, "Let me in!" and maintained its tenacious grip, almost maddening me with fear. "How can I!" I said at length. "Let me go, if you want me to let you in!" The fingers relaxed, I snatched mine through the hole, hurriedly piled the books up in a pyramid against it, and stopped my ears to exclude the lamentable prayer. I seemed to keep them closed above a quarter of an hour; yet, the instant I listened again, there was the doleful cry moaning on! "Begone!" I shouted, "I'll never let you in, not if you beg for 20 years". "It is twenty years", mourned the voice: "twenty years. I've been a waif for twenty years!".

breakdown of the nuclear reactor on Three Mile Island in Harrisburg was, according to official sources, triggered by 'human error' at four o'clock in the morning. The Challenger Space Shuttle crash was partly the result of decisions made by the responsible parties in the early morning after less than two hours of sleep. Near-accidents in aviation due to pilot fatigue are more frequent than is generally known, and the majority of serious traffic accidents on highways happen because of driver fatigue. The consequences of ignoring biological conditions not only affect individuals: in Germany alone, fatigue-related accidents lead to approximately ten billion euros in damages per year.

Sleep disorders impair the individual's state of mind and ability to perform at full capacity throughout the day. Furthermore, insufficient sleep leads to illnesses that increase the risk of morbidity and mortality, including high blood pressure, gastrointestinal diseases and psychiatric disorders such as depression. The probability of developing depression increases four-fold with chronic insomnia. Only some of these sleep disorders are actually diagnosed and treated. As a result, every year, several billion pounds of indirect costs arise that could have been avoided through appropriate treatment in sleep medicine.[12] These figures alone provide striking evidence of both the importance of biological rhythms and the necessity for healthy sleep to keep us performing at our full capacities. Where permanent disruptions prevent people from getting enough sleep, one must reckon not only with resulting high costs but also with chronic illnesses, and in very extreme cases, death.

1 Haen, E and Zulley, J. *Chronomedizin*, Regensburg, 1994.

2 Zulley, J and Knab, B. *Unsere Innere Uhr*, Freiburg, 2003.

3 Wever, R, *The Circadian System of Man*, New York, 1979.

4 Hobson, J A. *Schlaf. Gehirn im Ruhezustand*, Heidelberg, 1990.

5 Zulley, J. *Mein Buch vom gesunden Schlaf*, Munich, 2005.

6 Jouvet, M. "Paradoxical Sleep as a Programming System", *Journal of Sleep Research 7*, 1998, Supplement 1, pp. 1–15.

7 Wiegand, M et al. *Schlaf und Traum*, Stuttgart, 2006.

8 Cicogna, P C et al. "A Comparison of Mental Activity During Sleep Onset and Morning Awakening", *Sleep 21(5)*, 1998, 462–470.

9 Mathur, R and Douglas, N J. "Frequency of EEG Arousals from Nocturnal Sleep in Normal Subjects, Sleep 18(5), 1995, 330–333.

10 Ohayon, M M and Zulley, J. "Prevalence of Naps in the General Population", *Sleep and Hypnosis 1*, 1999, pp. 88–97.

11 Youngstedt, S D and Kripke, D F. "Long Sleep and Mortality: Rationale for Sleep Restriction" *Sleep Medicine Reviews 8(3)*, 2004, pp. 159–174.

12 Fischer, J et al. *Nicht erholsamer Schlaf*, Berlin, 2002.

Nicholson Baker

from *The Mezzanine*

In bed I kissed L good night while she wrote down the events of her day in a spiral notebook, and then I selected a promising used plug from the array on my bedside table and pressed it into whichever ear was going to point toward the ceiling first. If she asked a question after I had put the plug in and turned on my side, I had to raise my head off the pillow, exposing the lower ear, to hear her. Earlier I had tried sleeping with earplugs in both ears, so that I would be sound-free as I revolved in my sleep, no matter which ear turned up, but what I found was that the pillow ear would be in pain by the early hours of the morning; so I learned how to transfer the single warm plug from ear to ear in my sleep whenever I turned. By this time L was resigned to my wearing them; sometimes, to demonstrate special tenderness, she would get the wooden toaster tongs, take hold of an earplug with them, drop it in my ceilingward ear before I had gotten around to doing so, and tamp it in place, saying, "You see? You see how much I love you".*

* Although earplugs are essential for getting to sleep, they are useless later on, when you are awakened with night anxieties, and your brain is steeping in bad fluorescent juice. I slept beautifully through college, but the new job brought regular insomnia, and with it a long period of trial and error, until I hit on the images that most consistently lured me back to sleep. I began with *Monday Night at the Movies* title sequences: a noun like 'MEMORANDUM' or 'CALAMARI' in huge three-dimension curving letters, outlined with chrome edgework of lines and blinking stars, rotating on two axes. I meant myself to be asleep by the time I passed through the expanding O, or the dormer window of the A. This did not work for long. In the belief that images with more substance to them, and less abstract pattern, would encourage the dreaming state, I pictured myself driving in a low fast car, taking off from an aircraft carrier in a low fast plane, or twisting water from a towel in a flooded basement. The plane worked best, but it didn't work well. And then, surprised that I had taken so long to think of it, I remembered the convention of counting sheep. In Disney cartoons a little scene of sheep springing lightly over a stile or a picket fence appears in the thought-cloud above the man in the bed, while on the soundtrack violins accompany a soft voice out of 78 records saying, 'One, two, three, four....' I thought of story conferences in Disney studios back in the golden days of cartoons: the look of benign concentration on the crouching animator's face as he carefully colored in the outline of a suspended stylised sheep one frame farther along in its arc, warm light from his clamp-on drafting-table lamp shining over the pushpins and masking tape and the special acetate pencil in his hand—I was soon successfully asleep. But though this Disney version achieved its purpose, it felt unsatisfactory: I was imagining sheep, true, but the convention, which I wanted to uphold, called for counting them. Yet I didn't feel that there was any point to counting what was obviously the same set of animated frames recycled over and over. I needed to pierce through the cartoon, and create a procession of truly differentiable sheep for myself. So I homed in on each one in its approach to the hurdle and looked for individuating features —some thistle prominently caught, or a bit of dried mud on a shank. Some times I strapped a number on the next one to jump and gave him a Kentucky Derby name: Brunch Commander, Nosferatu, I Before E, Wee Willie Winkie. And I made him take the jump very slowly, so that I could study every phase of it—the crumbs of airborne dirt floating slowly toward the lens, the soft-lipped grimace, the ripple moving through the wool on landing. If I wasn't off by then, I backed up and reconstructed the sheep's entire day....

Nikolai Gogol

from *The Mysterious Portrait*

The portrait was quite uncovered, and was gazing beyond everything around it, straight at him; gazing as it seemed fairly into his heart. His heart grew cold. He watched anxiously; the old man moved, and suddenly, supporting himself on the frame with both arms, raised himself by his hands, and, putting forth both feet, leapt out of the frame. Through the crack of the screen, the empty frame alone was now visible. Footsteps resounded through the room, and approached nearer and nearer to the screen. The poor artist's heart began beating fast. He expected every moment, his breath failing for fear, that the old man would look round the screen at him. And lo! He did look from behind the screen, with the very same bronzed face, and with his big eyes roving about.

Tchartkoff tried to scream, and felt that his voice was gone; he tried to move; his limbs refused their office. With open mouth, and failing breath, he gazed at the tall phantom, draped in some kind of a flowing Asiatic robe, and waited for what it would do. The old man sat down almost on his very feet, and then pulled out something from among the folds of his wide garment. It was a purse. The old man untied it, took it by the end, and shook it. Heavy rolls of coin fell out with a dull thud upon the floor. Each was wrapped in blue paper, and on each was marked, "1,000 ducats". The old man protruded his long, bony hand from his wide sleeves, and began to undo the rolls. The gold glittered. Great as was the artist's unreasoning fear, he concentrated all his attention upon the gold, gazing motionless, as it made its appearance in the bony hands, gleamed, rang lightly or dully, and was wrapped up again. Then he perceived one packet which had rolled farther than the rest, to the very leg of his bedstead, near his pillow. He grasped it almost convulsively, and glanced in fear at the old man to see whether he noticed it.

But the old man appeared very much occupied: he collected all his rolls, replaced them in the purse, and went outside the screen without looking at him. Tchartkoff's heart beat wildly as he heard the rustle of the retreating footsteps sounding through the room. He clasped the roll of coin more closely in his hand, quivering in every limb. Suddenly he heard the footsteps approaching the screen again. Apparently the old man had recollected that one roll was missing. Lo! Again he looked round the screen at him. The artist in despair grasped the roll with all his strength, tried with all his power to make a movement, shrieked—and awoke.

He was bathed in a cold perspiration; his heart beat as hard as it was possible for it to beat; his chest was oppressed, as though his last breath was about to issue from it. "Was it a dream?" he said, seizing his head with both hands. But the terrible reality of the apparition did not resemble a dream. As he woke, he saw the old man step into the frame: the skirts of the flowing garment even fluttered, and his hand felt plainly that a moment before it had held something heavy. The moonlight lit up the room, bringing out from the dark corners here a canvas, there the model of a hand: a drapery thrown over a chair; trousers and dirty boots. Then he perceived that he was not lying in his bed, but standing upright in front of the portrait. How he had come there, he could not in the least comprehend. Still more surprised was he to find the portrait uncovered, and with actually no sheet over it. Motionless with terror, he gazed at it, and perceived that the living, human eyes were fastened upon him. A cold perspiration broke out upon his forehead. He wanted to move away, but felt that his feet had in some way become rooted to the earth. And he felt that this was not a dream. The old man's features moved, and his lips began to project towards him, as though he wanted to suck him in. With a yell of despair he jumped back—and awoke.

"Was it a dream?" With his heart throbbing to bursting, he felt about him with both hands. Yes, he was lying in bed, and in precisely the position in which he had fallen asleep. Before him stood the screen. The moonlight flooded the room. Through the crack of the screen, the portrait was visible, covered with the sheet, as it should be, just as he had covered it. And so that, too, was a dream? But his clenched fist still felt as though something had been held in it. The throbbing of his heart was violent, almost terrible; the weight upon his breast intolerable. He fixed his eyes upon the crack, and stared steadfastly at the sheet. And lo! he saw plainly the sheet begin to open, as though hands were pushing from underneath, and trying to throw it off. "Lord God, what is it!" he shrieked, crossing himself in despair—and awoke.

And was this, too, a dream? He sprang from his bed, half-mad, and could not comprehend what had happened to him. Was it the oppression of a nightmare, the raving of fever, or an actual apparition? Striving to calm, as far as possible, his mental tumult, and stay the wildly rushing blood, which beat with straining pulses in every vein, he went to the window and opened it. The cool breeze revived him. The moonlight lay on the roofs and the white walls of the houses, though small clouds passed frequently across the sky. All was still: from time to time there struck the ear the distant rumble of a carriage. He put his head out of the window, and gazed for some time. Already the signs of approaching dawn were spreading over the sky. At last he felt drowsy, shut to the window, stepped back, lay down in bed, and quickly fell, like one exhausted, into a deep sleep.

The Dream Recorder
Cover, *Science and Invention*, no.5
Experimenter Publishing Company,
New York
September 1926

Deutsches-Hygiene Museum,
Dresden

Incredible discoveries and fantastic ideas were the staple content of *Science and Invention*, a popular science-fiction magazine. In this issue its editor, Hugo Gernsback, wrote of his theories about dreaming ("If you dream, see your doctor.") and about the supposed possibility of recording dreaming activity by measuring increased heartbeat and accelerated breathing.

Animal Locomotion, Plate 263: Getting into Bed
Eadweard Muybridge
Philadelphia 1887

Collotype
London, Wellcome Library

As early as 1872, Eadweard Muybridge developed a new technique of sequence photography. 36 cameras releasing their shutters consecutively made it possible for the first time to observe the motion sequence of humans or animals. 'Animal Locomotion' records natural movements: walking, climbing stairs, jumping, and also getting up and going to bed.

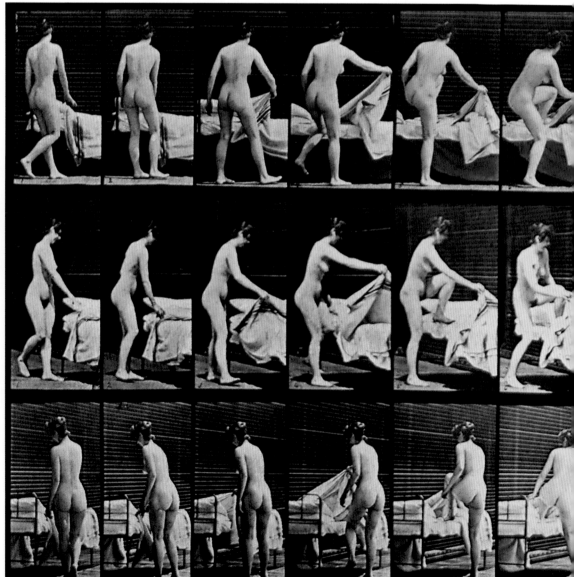

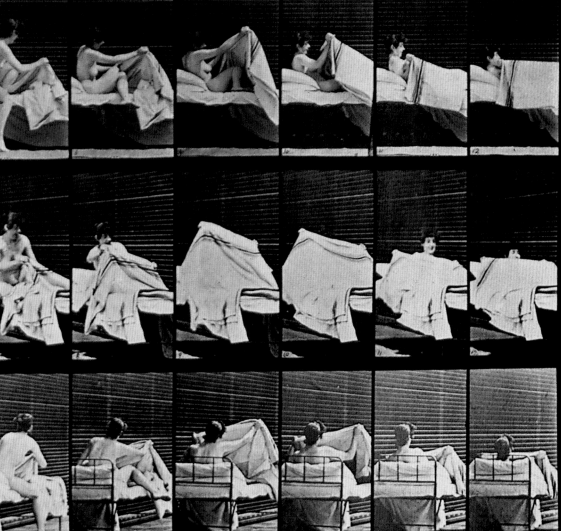

Animal Locomotion, Plate 265:
Getting out of Bed and
Preparing to Kneel
Eadweard Muybridge
Philadelphia 1887

Collotype
London, Wellcome Library

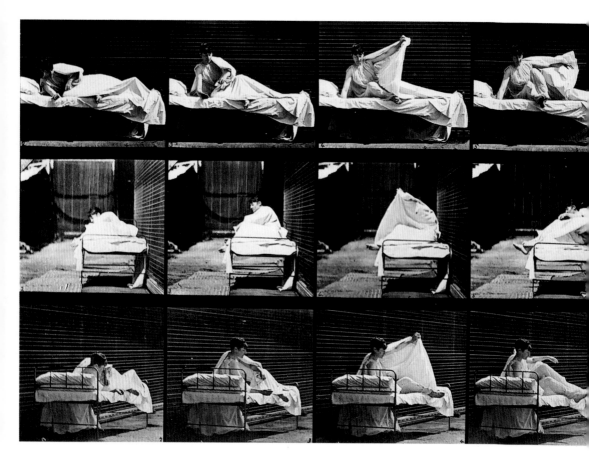

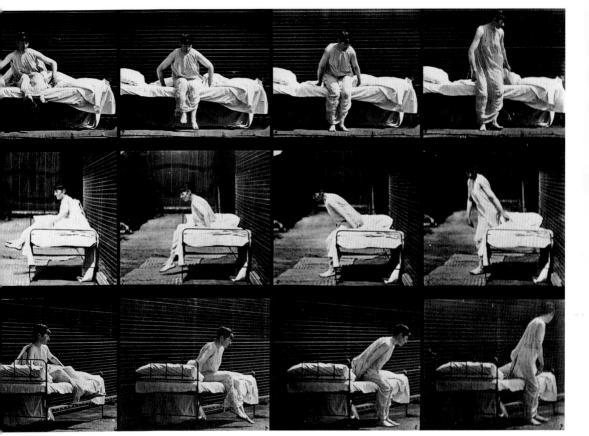

**Nathaniel Kleitman and
Bruce Richardson's
Cave Experiment**

Photographs:
courtesy of Mammoth Cave
National Park, Kentucky, USA
Park Museum Collections

In the summer of 1938, Nathaniel
Kleitman and Bruce Richardson
spent a month in Mammoth Cave,
Kentucky. The objective was to
discover whether the natural
24-hour-cycle of sleep and
wakefulness could be influenced
by changes in light or temperature.
Only Richardson, the younger of
the two, managed to adjust his body
to a rhythm of 28 hours (9 hours
of sleep, 29 hours of wakefulness).
Nathaniel Kleitman suspected
that his assistant's age was
experimentally significant. He is
recognised as a founder of modern
sleep research and was involved in
the discovery of REM sleep in 1953.

1 Kleitman and Richardson
 occupied a small part of the
 longest cave in the world,
 accessible only via a
 subterranean river system.

2 Morning or evening ablutions.

3 The beds stand in buckets
 of water to keep the rats
 at bay.

4 The cave is lit by torches
 for filming.

5 After 33 days Kleitman
 and Richardson depart
 from the cave.

6 Kleitman examines the
 recording devices while
 Richardson sleeps.

 Overleaf
 Even in summer the
 temperature was constant
 at 12 degrees centigrade.

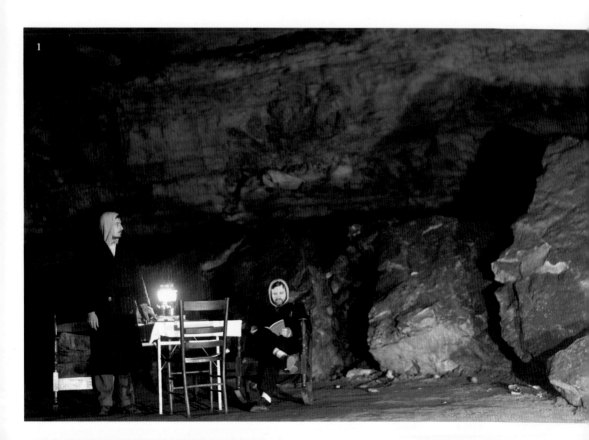

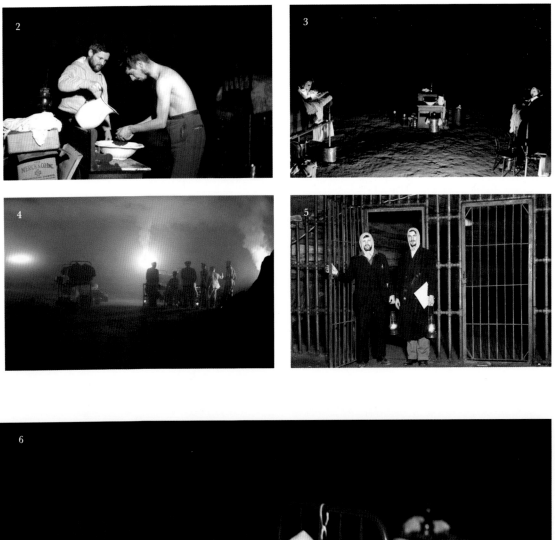

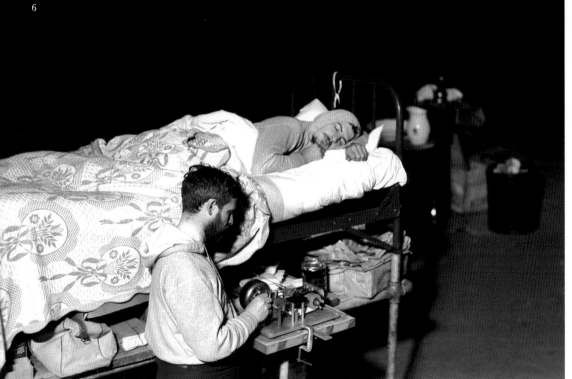

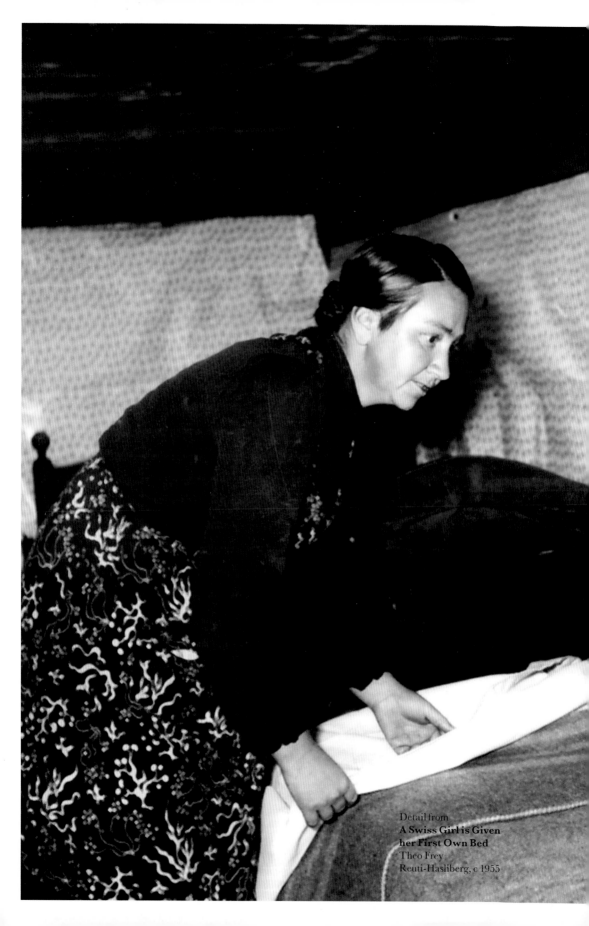

Detail from
**A Swiss Girl is Given
her First Own Bed**
Theo Frey
Reuti-Hasliberg, c 1955

Sleep as a Temporal Bridge:
on the Phenomenology of the Sleeping Consciousness

Manfred Geier

Heraclitus says that the waking share one and the same world, whereas the sleeping each turn to their own private world.
Heraclitus of Ephesus: Fragment 89 (circa 500 BC)

He waited to hear the sound of another drop of water splashing onto the rocky ground. When had the last one fallen? Five minutes ago, or was it half an hour? He was uncertain. For to him, the course of time had lost its measurable cycles and tangible rhythms. He felt as if he were living outside of time, and he wrote a fascinating report about it: *Hors du Temps* (Paris, 1963).

Michel Siffre lived in a world of his own. On 16 July 1962, he had gone down into his cave in the Alps, alone and without any method of

Michel Tournier

from *Friday, or the Other Island* (trans Norman Deny) (In this retelling of *Treasure Island*, the castaway has made a water-clock)

Journal: Henceforth whether I am waking or sleeping, writing or cooking a meal, my time is marked by this regular ticking, positive, unanswerable, measurable and precise. How eagerly I seek those adjectives which for me represent so many victories over the forces of evil.
 A little later:
 Robinson had awakened much later than usual. He realised this at once, but, no doubt because his conscience was still asleep, he did not rebuke himself.... Suddenly he realised why it was that he had awakened so late. He had forgotten to fill his water-clock the night before, and it had run dry.... Robinson stretched luxuriously on the couch. This was the first occasion for months when the inexorable dripping had not dictated his every movement as rigorously as if it had been a conductor's baton. Time had had a stop, and he was on holiday!

timekeeping, intending to stay there for several months. Without the light of day and the dark of night, he lived in a diffuse space-time that left him increasingly confused. Sometimes hours would pass during what he thought was a short nap, while at other times he felt like he was experiencing nothing apart from the flowing current of time. He found it particularly disturbing not to be able to make a clear distinction between waking, sleeping and dreaming. Perhaps it was only in a dream that he was staring wide-eyed into the complete darkness, wondering whether he was asleep or awake? He found no definite answer. This unsettling sense of disorientation, however, only existed in Siffre's consciousness. The scientists remotely monitoring his experiment (communicating with the cave-dweller by telephone) found that his body had adapted quite accurately to a rhythm that only diverged slightly from the 24-hours of 'universal time' that the outside world functioned within. Upon observation, the scientists found that Stiffre's bodily cycles were dictated by an internal biological clock that followed the day/night cycles with only a minimum of variation. That is, his chronobiological mechanism functioned endogenously (internally regulating) according to a circadian rhythm roughly (circa) like the course of a day (dias), thus structuring his phases of sleeping and waking, which alternated periodically in harmony with the rhythm of day and night.

There were three different types of time, then, interacting in this experiment: Firstly, universal time, which runs continuously and uniformly and can be measured chronometrically using mechanical clocks, secondly endogenous body time in a circadian alternation of sleeping and waking periods and finally mental time, which is neither mechanically determined nor biologically controlled. While the first two types of time seemed to remain more or less in control throughout the experiment, it was the consciousness of time that became problematic in Stiffre's case.

While it is thought that circadian rhythms do indeed appear to be controlled endogenously, from a phylogenetic taxonomist's point of view, the body's own clock (ticking above the optic chiasm in a clump of nerve cells the size of a kernel of rice called the suprachiasmatic nucleus or SCN) developed as a result of external circumstances. From the very beginning, the evolution of homo sapiens' body time responded to the regular alternation of daylight and nighttime darkness. It was because of this that humans came to see daytime as the time of activity and movement, when they would attentively address the realities of their natural and social environments with an attended consciousness while, during their night's sleep, they would

Johann Wolfgang von Goethe

from *Faust*, Book II, Act i (trans Philip Wayne)
(Ariel sings Faust to sleep)

When the petals, like sweet rain,
Deck the earth with fluttering spring,
When the fields are green again,
And to men their blessing bring,
Then the little elves, great-souled,
Haste to help, if they can,
Saint or sinner, for they hold
Heart's compassion for each luckless man.
Ye who surround this head in airy wheeling,
Show now the noble elfin power of healing,
Soothe now the tumult of this mortal heart,
And wash away the stain of horrors past;
Of self-reproach, remove the bitter dart,
And, in the night's four vigils, give at last
This soul the comfort pity can impart.
Pillow his head upon the sweet, cool lawn,
Then bathe his limbs with dew from Lethe's lea,
Soon the cramp-stricken frame will lissom be,
With strength renewed, through sleep, to meet the dawn.
Fulfil, O elves, your lovely task aright,
And lead him back restored to heavenly light.

each retreat into a world of their own, in order to recover from the day's demands and gain distance from the reality principle. Our chronobiological make-up programmes us, so to speak, to get tired and fall asleep in the evenings and to wake up again in the mornings refreshed and able to take on another day's tasks.

The physiological changes occurring during this switch have been researched quite extensively. The deeper a person's sleep is, the more marked the decrease in their physiological activities: metabolic processes are reduced, body temperature falls and reaches its lowest value by early morning, heart and breathing rates slow, activity in the brain tissue decreases, and the nerve cells in the motor region of the brain send weaker action impulses to the muscles until muscle tone —in places—diminishes to zero. There is an ongoing dispute over whether sleep functions as a rest state in which physiological regenerative processes can take place. In any case, it is generally agreed, that nighttime sleep increases the efficiency of the body's adaptation to the periodic switch from daytime to night, and can be therefore indirectly experienced as regenerative.

Samuel Johnson

from *The Idler*

Sleep is a state in which a great part of every life is passed. No animal has been yet discovered, whose existence is not varied with intervals of insensibility; and some late philosophers have extended the empire of sleep over the vegetable world.

Yet of this change, so frequent, so great, so general, and so necessary, no searcher has yet found either the efficient or final cause; or can tell by what power the mind and body are thus chained down in irresistible stupefaction; or what benefits the animal receives from this alternate suspension of its active powers.

Whatever may be the multiplicity or contrareity of opinions upon this subject, nature has taken sufficient care that theory shall have little influence on practice. The most diligent inquirer is not able long to keep his eyes open.

The Quest for Internal Time

Our internal body clocks are synchronised with universal time via the body's detection of light and dark. From a chronobiological point of view, therefore, sleep is not timeless, but bound to the cycle of light and darkness caused by the earth's daily rotation. So what happens to mental time when we are asleep? Our internal sense of time seems no longer to have any reference points by which to orientate itself, leaving the body unable to reliably parse the passing of time. Our sense of movement is especially affected by this reduced ability, as it is closely linked to our sense of temporal sequences. During deep sleep in particular, there are not any events similar to those we use to calibrate our perception of time in waking life. When we are asleep, we have neither a conception nor an awareness of when events happen, in which chronological order they take place and how long they endure.

Is it not paradoxical, then, to speak of a 'sleeping consciousness'? Usually, in order to experience or know something consciously, humans must be in a position to attend to circumstances about which true and false statements are made. True statements are societally privileged, as they correspond to facts that can be verified intersubjectively. The immediate perceptions registered in this waking consciousness during a present moment (limited to a time interval of three seconds) are somehow related to permanent memory traces and systems of recollection, even though this remains an incompletely solved scientific conundrum. However, this consciousness is evidently interrupted in some mysterious way when a person enters a sleeping state, making it all but impossible to make claims to the truth or falsity of the circumstances experienced within it.

In the course of their research, scientists attempted to solve this problem by desubjectifying sleep, that is, treating it as fact and trying to observe, describe and explain it as such. In this way, the characteristic physiological behaviour of sleepers, including their brain activity, was made the object of falsifiable research. Neurophysiologists and behavioural psychologists turned their attention to animals as well as humans, from spiders and voles to non-human primates. It comes as no surprise that various behavioural rhythms were discovered which are endogenously controlled and run according to periodically arranged chronological patterns. Nonetheless, a consensus was reached to deny animals a cognitive sense of time during the sleep state as they seem incapable of tracking universal time, or even, mental time.

What, then, is actually fundamental to human beings' internal sense of time, which only they can attain a cognitive understanding of? This question is central to philosophical phenomenology, which does not view itself as an objective, factual science, but tries instead to record, describe and understand the experiences of the human subject as they are known to him. Phenomenological philosophy focuses on life-immanent facticity, as perceived by every ego to have 'always been there', before any scientific attempt to objectify the facts of consciousness. It strives towards a pure act-process in which the human consciousness as such can become self-transparent.

This self-transparency was demonstrated by Edmund Husserl, the founder of transcendental phenomenology, mainly using the internal sense of time as an example. As it was a topic belonging to phenomenology, it could not be reduced to the measurable time of the world in the sense used in the natural sciences. It also eluded all approaches via psychology or physiology as factual sciences of the psyche. In philosophers' eyes, it was a mystery capable of confusing us in the extreme, even though nothing appears more familiar to us than the unbroken temporality of our stream of consciousness.

Blaise Pascal

from *Pensées* (trans J Warrington)

Again, no one is sure, apart from faith, whether he is awake or asleep, seeing that during sleep we believe that we are awake as firmly as we do when we are awake. We believe we see spaces, figures, movements; we experience the passage of time, we measure it; and in fact we behave just as when we are awake. We spend half of our life asleep, in which condition, as we ourselves admit, we have no idea of truth, whatever we may imagine, since all our perceptions are illusory. Who knows, therefore, whether the other half of life, in which we believe ourselves awake, is not another dream, slightly different from the first, from which we awake when we suppose ourselves asleep?

Sir Thomas Browne

from *The Garden of Cyrus*

Though Somnus in Homer be sent to rowse up Agamemnon, I finde no such effects in these drowsy approaches of sleep. To keep our eyes open longer were but to act our Antipodes. The Huntsmen are up in America, and they are already past their first sleep in Persia. But who can be drowsie at that howr which freed us from everlasting sleep? Or have slumbering thoughts at that time, when sleep itself must end, and as some conjecture all shall awake again.

Husserl's attempts at finding a solution to this riddle had essentially been concluded in his 1905 lectures on the phenomenology of the internal awareness of time. Martin Heidegger published them in 1928. Since then, they have been numbered amongst the most impressive demonstrations of phenomenological examination in the history of philosophy. It is especially Husserl's analysis of the complex trinity of dimensions—'proto-impressional'—perception in the live stream of present moments; the 'retentional' tail of memories of *Just Now* and *Beforehand*, which are still present in the consciousness and which fade and are obscured increasingly in the course of time; and the 'protentional' anticipation of *Afterwards*, which is a projection of the past into the future in the form of an expectation—that, even now, impresses the reader by virtue of its precision and intellectual rigour.

After Heidegger published his lectures, however, Husserl saw the necessity of undertaking farther-reaching analyses. The phenomenon of sleep, in particular, required closer examination. The question to be answered was: what happens to the 'self-transparency' of our internal sense of time when we sleep?

Husserl unravelled the mystery of the sleeping consciousness in the context of phenomenology in his *Späte Texte über Zeitkonstitution*, 1929–1934, (Later Texts on the Persistence of Time, 1929–1934) first published in 2006 by Dieter Lohmar as the *C Manuscripts*. Here, too, the protophenomenonal starting point was the waking ego's living present. For Husserl, the actual streaming conscious present begins with awakening and ends with falling asleep. It is only from this present that the ego can look back retentionally or forward protentionally. And only the following is apodictically certain: that for every waking present in life, there is a future horizon. "It is evident", Husserl noted in August 1930, stimulated and provoked by his pupil Martin Heidegger's death-centred analysis of temporality, "that the concrete cessation, the natural cessation

Kazuo Ishiguro

from *The Unconsoled* (The narrator is trying to relax at his hotel in a city where he is due to give a recital)

I had not been asleep long when the telephone rang beside my ear. I let it ring for a while, then finally sat up on the bed and picked up the receiver.

"Ah, Mr Ryder. It's me. Hoffman."

I waited for him to explain why he was disturbing me, but the hotel manager did not continue. There was an awkward silence and then he said again:

"It's me, sir. Hoffman." There was another pause, then he said: "I'm down here in the lobby."

"Oh yes."

"I'm sorry, Mr Ryder, perhaps you were in the middle of something."

"Actually I was just getting a little sleep."

This remark seemed to stun Hoffman, for there followed another silence. I laughed quickly and said: "What I meant was, I was lying down, as it were. Naturally I won't be having a full sleep until… until all the day's business is concluded."

"Quite, quite." Hoffman sounded relieved. "Just catching your breath, so to speak. Very understandable. Well, in my case, I shall be here in the lobby waiting for you, sir."

of the live, streaming present cannot be conceived of as a fact, as something that exists, or can be experienced. But this is not a paradox: being alive in the streaming present, I must inevitably believe that I shall live, if I know that my death awaits me".

I was only Sleeping

In the phenomenologists' examination of 'cessation', which radically opposes the proto-phenomenon of temporal streaming, the definition of sleep approached the same definition of death, however Husserl maintained that death is not a type of sleep. For, on the one hand, "my entire worldly existence, my ego, ends in the inconceivable moment of death. And if there were a possibility of waking up from death as from sleep, this awakening would not bring me back to the same state of being-in-the-world as the one that I know phenomenologically as my existence." Husserl thought that the idea of returning as a reawakened dead person was pure nonsense. On the other hand, even deep, actionless sleep, during which the ego no longer has any active interest in the world, is not rigor mortis. For I am only asleep; and I can wake up again, I have not stopped being myself. "Sleep, then, is the sleep of the ego, the centre of affects and actions. The ego is asleep, it does not engage in affects, it stays passive. All of the interests remain, but inactive; they are resting. The ego is in absolute repose, as are the impulsive ego and the volitive ego." Falling asleep is indeed a sort of cessation for the phenomenologist, deep sleep is an interim stage where the waking ego gives up its active and current intentions, interests and affections, all of them

Sleep as a Temporal Bridge: on the Phenomenology of the Sleeping Consciousness

bound to the temporal horizons of past and future. Our living existence in the current of time loses its diversity. When we are tired, our every action becomes strenuous and devoid of amusement. Our interests 'die off'. In sleep, we reach the limits of uniformity and inactivity.

When we wake up, life regains its diversity and temporal dynamics. "The ego, the subject of interest, is woken; I as I myself am." It is as if the unity of the enduring world and our continuing existence persisted across the breaks imposed by sleep. "The course of the world has not been interrupted, I was only sleeping", Husserl noted on 22 March 1931 and inquired one last time into the role and mode of 'sleeping mental being' in the living stream of time. From a phenomenological point of view, he was certain about it: "I and, likewise, everyone else, live in a life of consciousness as a waking ego, connecting the stretches of wakefulness to create unity above and beyond the waking period". But how can this unity in continuous time 'persist' if it is interrupted every day by 'sleep breaks'?

We can only identify our ego with our being-in-the-world, using sleep as a 'bridging piece' between separate stretches of wakefulness, because we live 'primordially'—that is originally and essentially—in a shared world. Our own respective existences are integrated into a 'connection with others', and only via these others do we attain a time that is intersubjective, "more explicitly: attain sleep breaks and a temporal interpretation of the existence of things through and beyond my and every human being's sleep breaks". For I may well fall asleep and wake up in the egological-primordial sphere and, in retrospect, suppose that I have my sleep breaks in it too. "But no notion of my primordiality will give me the meaning that informs this supposed meaning." In this way, paradoxically, it was deep sleep that led

Sir Philip Sidney

from "Astrophel and Stella"

Come, Sleepe! O Sleepe, the certaine knot of peace,
The baiting-place of wit, the balme of woe,
The pooreman's wealth, the prisoner's release,
Th' indifferent judge between high and low;
With sheild of proof shield me from out the prease
Of those fierce darts Despaire at me doth throw:
O make in me those civill warres to cease:
I will good tributepay, if thou do so.
Take thou of me smooth pillowes, sweetest bed,
A chamber deafe to noise and blind of light,
A rosie garland and a weary hed:
And if these things, as being thine in right,
Move not thy heavy grace, thou shalt in me,
Livelier then else-where, Stella's image see.

Husserl from the idea of the pure ego, which dominated his early work, to that of the primordial community, which he determined to be a "unity of intersubjective wakefulness (waking, living present)". The phenomenology of the sleeping consciousness led him to consider the phenomenology of the waking ego, which can only be formed by and understood in co-existence with others. In order to cross the temporal bridge of sleep safely while remaining an identical ego, one depends on the shared world of the waking. Michel Siffre's experience of this was disturbing; Heraclitus was the first to remark upon it, and Husserl analysed it phenomenologically in his later works: "presupposing, of course, the collectivisation of the waking ego with other waking egos, while objective spatial-temporal existence persists".

One may condemn all this as the careful, probing attempts of an aged phenomenologist who was becoming increasingly aware that his own concept of the 'pure ego' was a misconception. For it would only be truly 'pure' if it were egologically alone, a state for which 'sleep breaks' would be a rather paradoxical proof of existence. We may desire to fall asleep every day so that our impulsive ego and our volitive ego can find repose in the current of time, but we certainly would not want to sleep constantly and remain in a world of our own indefinitely. For the duration of deep sleep, we are free from those protentional urges and compulsions that bring us closer to the future horizon without our ever being able to reach it as a completed future. As soon as we wake up, however, having bridged the period of sleep, we at least have the opportunity to be in the same space-time with others again, and only there can we safely situate ourselves and our existence.

"Admittedly, now we have not taken account of the mode of dreams", noted Husserl on 22 March 1931; neither have we considered the 'dream time' that agitates our sleeping consciousness and, like an imaginary time, meddles with the true time of our intersubjective experiences. However, at this point we cannot follow up this allusion to the temporal discontinuities of dream, "which is troublesome enough in itself". To Husserl, too, the phenomenology of the dreaming consciousness was a blank space on the map. We shall content ourselves with stating that his pupils and successors attempted to supplement it, whereby their attention remained concentrated on the primordiality of the waking consciousness in a shared world. In opposition to Sigmund Freud's psychoanalytical theory of dream interpretation, according to which there is nothing in the unconscious 'Id' that follows a temporal sequence and corresponds to our conception of time, phenomenology stayed bound to the temporality of ego consciousness. After all, it was I, myself, who was dreaming in my own world, and upon reawakening, I can tell others of my dreams in the form of dream reports. Dream time, too, is and remains a mode of temporality, regardless of how disassociated it is from the waking world, and how mysteriously it enfolds and ensnares us in its fantastical landscape.

Transporting a Bed to a Swiss Mountain Pasture
Theo Frey
Reuti-Hasliberg, c 1955

Photographs:
Winterthur, Fotostiftung Schweiz
© Bild-Kunst, Bonn

Feeling that, even in remote Alpine regions, it was no longer appropriate for whole families to be sharing the same bed, in 1954 the Swiss Red Cross set out to improve sleeping conditions under the slogan "to every child its own bed". Beds were transported to the most inaccessible mountain pastures.

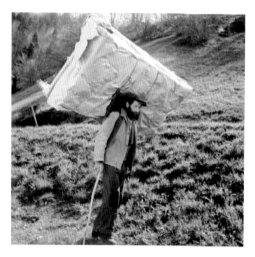

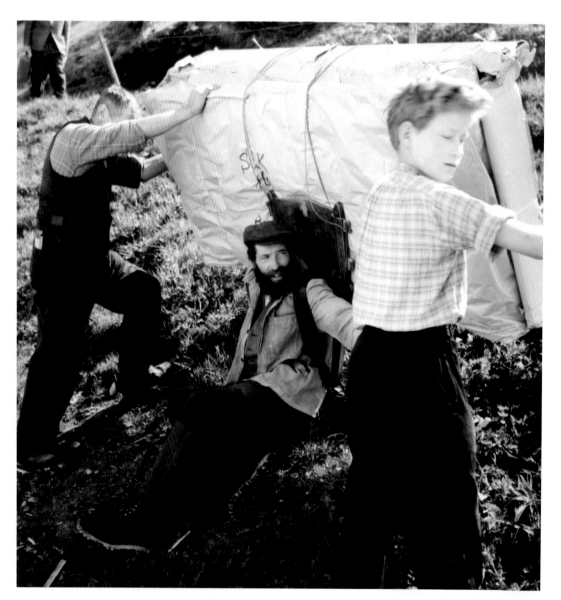

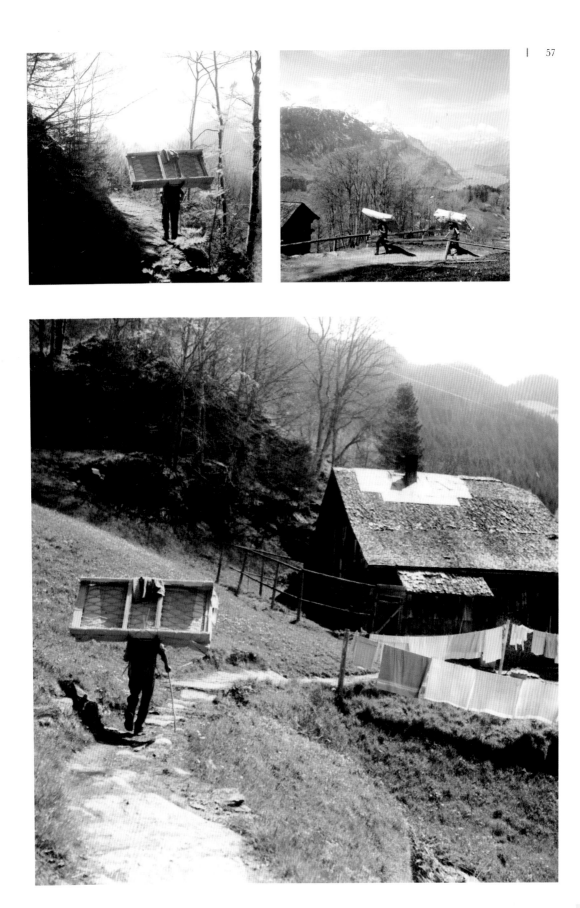

Transporting a Bed to a Swiss Mountain Pasture
Theo Frey
Reuti-Hasliberg, c 1955

Photographs:
Winterthur, Fotostiftung Schweiz
© Bild-Kunst, Bonn

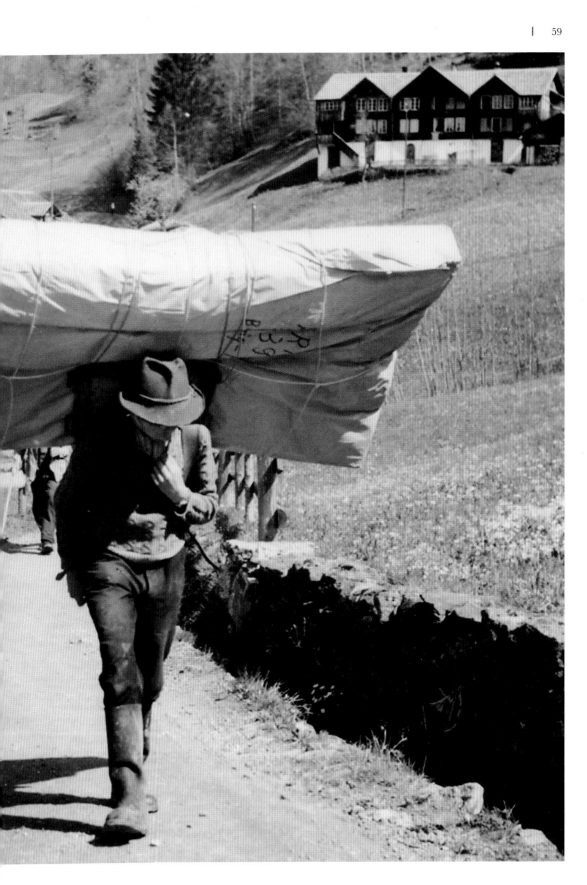

**A Swiss Girl is Given her
First Own Bed**
Theo Frey
Reuti-Hasliberg, c 1955

Photographs:
Winterthur, Fotostiftung Schweiz
© Bild-Kunst, Bonn

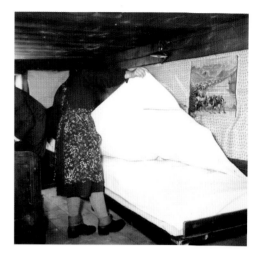

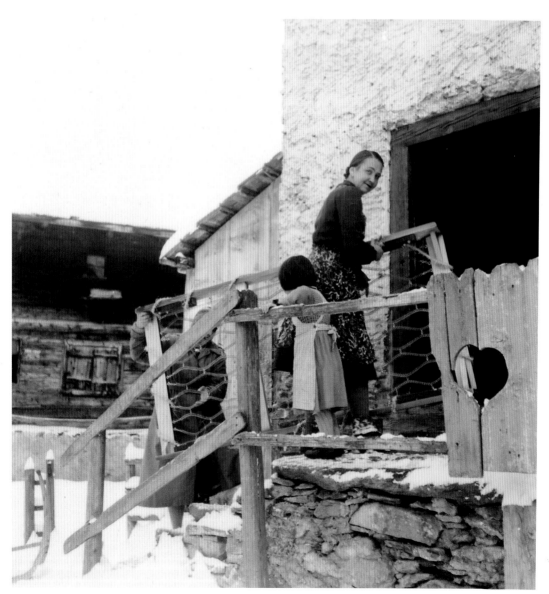

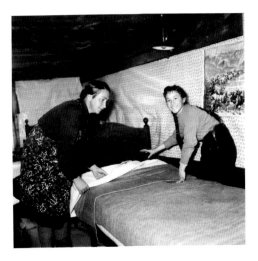

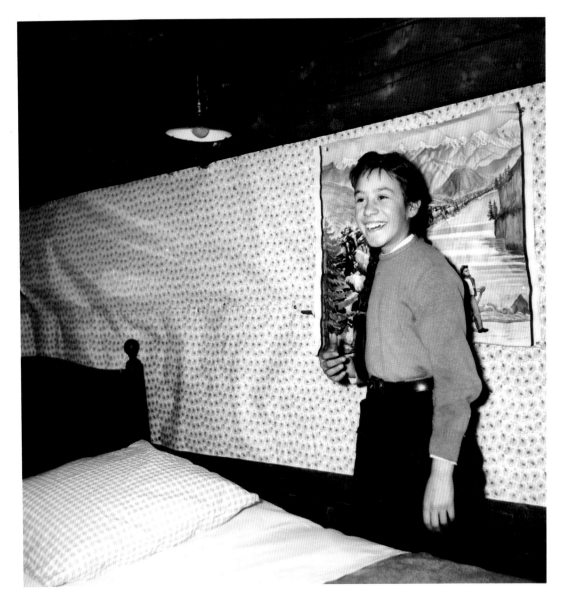

Detail from
**Staying Awake Record:
Peter Tripp**
Ted Russell
New York 1959

The Brain Never Sleeps:
how Sleep Improves our Memory

Ullrich Wagner

Learning in your sleep—who'd say no to that? Unfortunately, the brain's
capacity to take in outside information during sleep is too limited to
be able to effectively create new memory contents; yet modern sleep
research has shown that sleep plays a fundamental role in the process
of memory formation. This role indeed does not involve the absorption
of new information during sleep but rather refers to the stabilisation of
already-existing memory content. This process of stabilisation, called
'consolidation', enables the new memory representations created through
learning throughout the day to be strengthened during subsequent
sleep, and thus to be better retained.

Experimental Evidence

German psychologists, Georg Elias Müller and Alfons Pilzecker,
introduced the concept of consolidation into the psychology of memory in
the year 1900. Even then, in the early days of experimental psychological
research, it was already clear that new elements of memory content
acquired through learning are not simply filed away for later retrieval
like objects in drawers. Rather, there needs to be an active process
of maintenance and stabilisation to avoid the gradual forgetting of
information. The fact that this process takes place predominantly during
sleep has now been firmly established by a wealth of scientific findings.
The first experimental studies showing the facilitating effect of sleep on
the consolidation process were carried out already in the beginning of
the twentieth century, when scarcely anything was known about the
physiology of sleep itself. A classic study was the one conducted by J G
Jenkins and K M Dallenbach where the authors used two subjects to
study the retention of nonsense syllables (the learning material generally
used in memory psychology at that time) learned either in the morning
at the beginning of the waking phase or in the evening before sleeping.[1]
When the test subjects had slept after learning, they recalled distinctly
more syllables in retrieval tests taking place one, two, four and eight hours
after learning than under comparison conditions in which they had
remained awake during the retention interval. Numerous further studies
in the decades that followed confirmed these findings using larger
numbers of test subjects and more complex learning material such as

word lists and text passages. However, the objection can be raised against many of these older studies—including those by Jenkins and Dallenbach—that when comparing the effects of nocturnal sleeping periods with those of daytime waking periods, the sleep effect could be superimposed by effects due to circadian (time-of-day) factors. It is therefore important to note that sleep also produced superior outcomes in more recent studies where sleeping and waking conditions were tested at the same time of day, for example, in studies on the memory effects of midday siestas or afternoon naps. Furthermore, the effect appeared as well when memory tests were administered up to several days after the initial experiment, thus ruling out a purely proactive influence of sleep on retrieval processes in the subsequent memory test (ie, because of feeling mentally 'refreshed' after sleeping). This adds further support to the hypothesis that sleep has a facilitating effect on the consolidation process in memory formation.

Declarative versus Procedural Memory

The points discussed so far relate to all those tasks that can be attributed to what is known as declarative or explicit memory, which deals with facts and events ('knowing what') and neurobiologically relies on the hippocampus, an anatomical structure in the central area of the brain's temporal lobe whose elongated form resembles that of a seahorse (indeed 'hippocampus' is Latin for seahorse). The learning tasks carried out in this memory area correspond largely to those we know from school, for example memorising vocabulary or learning texts by heart, but the hippocampus region is also responsible for storing spatial learning memory. Since the 1980s, this declarative memory system has been juxtaposed against procedural or implicit memory ('knowing how'). This latter form of memory, which is not neurobiologically reliant on the hippocampus, relates to sensory capacities and motor skills such as walking, swimming, or riding a bicycle that one can gradually acquire by repeatedly carrying out the respective actions. Based on this differentiation, sleep research has examined a variety of different procedural or implicit memory tasks. Here too—just as with declarative

Ben Okri

from *The Famished Road* (a boy watches his father in a days-long sleep after a great wrestling match)

Dad was redreaming the world as he slept....
A dream can be the highest point of a life.

Rose Tremain

from *Music and Silence*

Johnnie O'Fingal had dreamed that he could compose music.... In this miraculous reverie, he had gone down to the hall, where resided a pair of virginals (of which he was an adequate player) and where we would sometimes invite the best Irish musicians of the day to entertain us and our friends with a concert, and had sat down in front of them and taken up a piece of my father's cream paper and a newly cut quill. In frantic hast, he had ruled the lines of the treble and bass clef, and begun immediately upon a complicated musical notation, corresponding to sounds and harmonies that flowed effortlessly from his mind onto the page. And when he began to play the music he had written it was a lament of such grace and beauty that he did not think he had ever heard in his life anything to match it.

I found this dream so wonderful that I immediately said: "Well, why do you not go down now this moment and see whether, when you sit at the instrument, you can remember the tune?"

"Oh no", he said, "what we can achieve in our dreams seldom corresponds to what we are veritably capable of".

But I pressed him. Ever since that night I have wished that I had not done so.

memory—sleep has proven to promote memory consolidation substantially compared to waking, both for sensory and for motor learning. Two findings from these studies are particularly noteworthy. First, as a rule, the test subjects showed even better performance in learned procedural skills after sleeping than in the end of initial training in the learning session prior to sleeping: that is, the consolidation during sleep even led to an improvement of the original capacities without further training. Second, it was shown that for certain procedural tasks, without sleep in the consolidation interval, no learning increase takes place at all.[2]

Insight through Sleep

A specific task that cannot be attributed unambiguously to either one of the two basic memory systems is the so-called 'number reduction task', which we used in a recent study to investigate whether sleep-associated memory consolidation can also bring about a qualitative restructuring of mental representations.[3] On the surface, the number reduction task is a motor-procedural one: test subjects are asked to convert sequences of digits shown on the screen as quickly as possible into a new sequences of digits, processing the digits in pairs from left to right according to predetermined transformation rules in order to determine a specific 'solution digit' to each sequence. By utilising the rules and putting them into practise motorically, test subjects become faster and faster from one task block to the next, thus learning procedurally. What the test subjects are not told is that all of the sequences are constructed according to the same basic pattern. When one gains insight into this underlying pattern,

John Steinbeck

It is a common experience that a problem difficult at night is resolved in the morning after the committee of sleep has worked on it.

only two transformation steps (instead of seven) are needed to find the solution digit. This insight process, which denotes a basic restructuring of the previous memory representations for the task at hand—and leads immediately to a qualitative improvement in task performance—was the focus of our interest: we wanted to find out whether sleep has a particularly facilitating effect on this process of attaining insight.

The idea that sleep does indeed support insight processes is implied by the legendary stories of several famous scientists, indicating that crucial inspirations for a number of scientific discoveries have come to researchers during their sleep. Dmitri Mendeléev, for example, after hours of unsuccessful experimentation with the elementary symbols, succumbed to exhaustion and allegedly saw an image in a dream that led to his discovery of the periodic system of chemical elements.[4] Another famous example is Otto Loewi, the man who discovered the chemical transmission of impulses between nerve cells, who described the decisive step in his discovery as follows:

In the night...I awoke, turned on the light, and jotted down a few notes on a tiny slip of thin paper. Then I fell asleep again. It occurred to me at six o'clock in the morning that during the night I had written down something most important. It was the design of an experiment to determine whether or not the hypothesis of chemical transmission that I had uttered 17 years ago was correct.[5]

Amazingly, this study design did indeed confirm his hypothesis, and later won him the Nobel Prize.

In our experiment, test subjects first completed the 'number reduction task' in three test blocks. This training phase was too short to allow subjects to gain insight into the hidden structure, but created an initial mental representation of the task in memory. For one of the three test groups studied, this initial training phase was followed by eight hours of nighttime sleep. A second group remained awake during the same period, while a third group went through the training in the morning and remained awake thereafter. After the eight-hour interval of sleeping or waking, the test subjects completed ten further test blocks of the task, and the number of test subjects who attained insight into the hidden structure during this

period was determined. The results were clear: the percentage of test subjects who attained insight into the hidden task structure for those who slept in the period between the training session and the test was more than twice as high as for those who remained awake during the interval (59 vs 22 per cent). It is important to note that this was the case in comparison to both waking control conditions, thereby ruling out an explanation through unspecific effects due to sleep deprivation (waking condition during the night) or due to different times of day of test administration (waking condition during the day). This study provides the first empirical evidence that sleep not only strengthens mental representations but can also qualitatively restructure them, potentially leading to the emergence of new ideas and solutions. It is precisely this effect that resonates through the reports of famous scientists.

Not all Sleep is Created Equal: The Role of Different Sleep Stages
Since the emergence of polysomnography (the recording of electrophysiological signals emitted by the brain during sleep) around the middle of the twentieth century, we know that sleep (like memory) should not be viewed monolithically. Rather, it is composed of clearly distinguishable, cyclically recurring physiological states known as sleep stages. Rechtschaffen and Kales determined the standard classification for these different stages of sleep in 1968, and their now-familiar classification rules for sleep stages S1, S2, S3, S4 and REM sleep have provided the framework for the study of sleep until today.
A crucial impetus for the sleep research came with Aserinsky and Kleitman's 1953 discovery of REM sleep, which differs significantly in the polysomnogram from the other sleep stages. This sleep stage is marked by a more active (desynchronised) EEG and complete muscular immobility, with the exception of repeatedly occurring rapid eye movements (REM). In contrast to other sleep stages, REM sleep is linked to very vivid and often emotional dream experiences.

With the discovery of REM sleep, many researchers in memory psychology became interested in the question of what unique role this peculiarly 'active' sleep state plays in memory consolidation,

Francis Bacon

from *The New Atlantis*

Ther was given vs also, a Boxe of small gray, or whitish Pills, which they wished our Sicke should take, one of the Pills, euery night before sleepe; which (they said) would hasten their Recouery.

particularly in comparison to its opposite physiological extreme, slow wave sleep (SWS), which encompasses the deepest sleep stages S3 and S4. This question raised the necessity of disentangling the effects of REM sleep and SWS experimentally. To this end, in the 1970s, Bruce Ekstrand and his colleagues developed the method of comparing the first and second half of the night.[6] Their approach utilises the highly pronounced natural imbalance in the distribution of SWS and REM sleep during nighttime sleep. The first half of the night is dominated by SWS, while REM sleep takes place mainly in the second half of the night. In order to distinguish the influences of the two stages, Ekstrand and his colleagues compared the consolidation effects of undisturbed sleep in the first half of the night, when SWS predominates, and the second half, when REM sleep predominates. As usual, the learning phase took place immediately before the respective sleep period, and the retrieval phase immediately thereafter. To control for circadian influences, test subjects under parallel control conditions stayed awake during each consolidation interval in the first and second half of the night.

In their studies, Ekstrand and his colleagues used declarative standard tasks (learning word lists) and interestingly, found a stronger consolidation effect for early SWS-rich sleep than for late REM sleep-rich sleep. Only in the 1990s was this study design applied to investigate procedural memory as well. W Plihal and J Born provided the first evidence of differential effects of SWS and REM sleep on declarative vs procedural memory in a direct comparison.[7] While early nocturnal sleep, dominated by SWS, proved particularly conducive to declarative memory formation (word pair association) as in the precursor studies by the Ekstrand group, late nocturnal sleep, dominated by REM sleep, proved particularly favourable to procedural memory formation, which in this study was tested using the sensory-motor task of mirror-drawing (in which the test subjects learn to copy figures that they can see only in inverted form via a mirror). In a follow-up study, the same pattern appeared when declarative memory was tested using a non-verbal task (spatial rotation) instead of learning word pairs, and non-declarative

William Shakespeare

from *Macbeth*, Act II, Scene ii

.... Innocent sleep,
Sleep that knits up the ravell'd sleave of care,
The death of each day's life, sore labour's bath,
Balm of hurt minds, great nature's second course,
Chief nourisher in life's feast.

memory was tested with a verbal task (word stem priming) instead of mirror-drawing.[8] In other words, the night-half effect could not be attributed to the type of learning material, and persisted through verbal and non-verbal learning.

REM Sleep for Emotional Memory Formation

Given the finding of exceptionally lively and intensive dream experiences accompanying REM sleep, this sleep stage has frequently been posited to hold central importance for the processing of emotional memories. This hypothesis has mainly emerged from the psychoanalytically-oriented research tradition, which has often taken theories on the emotional processing function of dreams—based on Sigmund Freud's *Interpretation of Dreams*—and applied them directly to REM sleep. More recent findings also add to the support for this hypothesis from a neuroscientific point of view. Brain imaging studies have shown that the amygdala and the adjacent structures of the limbic system—ie, those structures known to play a decisive role in emotional learning processes—are selectively activated during REM sleep.[9]

In a study of our own, we used the paradigm of night-half comparison described above to study the influence of REM sleep on emotional memory formation and to compare it with that of SWS.[10] In the learning phase before the retention interval in the first or second half of the night, test subjects learned both emotionally neutral and highly emotional texts. For example, one of the neutral texts described the technical procedure for manufacturing bronze sculpture, and an emotional text described a child murderer's killing procedures. In a memory test after the corresponding sleep or wake interval in the first or second half of the night, memory retention performance for the texts was assessed as the percentage of correctly recalled content. As expected, a general sleep effect was found; that is, retention performance across all sleep intervals was higher than across wake intervals. The main finding, however, was that late, REM sleep-dominated rest significantly enhanced memory retention performance for emotional texts in comparison with memory for neutral texts. This was not the case with early sleep, in which SWS is predominant. These results offer further support for the hypothesis that REM sleep in particular plays a decisive role in emotional memory formation.

Interestingly, the sleep effect proved to have an exceptionally long-lasting effect on the emotional memory. In a longitudinal comparative study, we asked the same test subjects about their memories of the texts again after four years in a structured telephone interview.[11] We found that the test subjects were able to remember the emotional texts very well when they

had slept immediately after learning, but not when they had remained awake; the neutral texts, in contrast, had largely been forgotten after four years, independent of sleep or wake conditions.

Neuronal Reactivation as Underlying Mechanism

The positive influence of sleep on memory consolidation is probably the result of neuronal ensembles activated for specific learning tasks and reactivated during sleep. In experiments with rats, for example, it was shown that the same hippocampal neurons that were activated in a spatial learning task fired again with increase frequency in subsequent SWS.[12] In an analogous declarative task in humans in which test subjects had to find their way through a virtual labyrinth on the computer, Peigneux and colleagues, using Positron Emission Tomography (PET), found that hippocampal regions were activated during SWS that had already been active during the preceding learning activity.[13] Here, the extent of learning success throughout the night was directly associated with the extent of hippocampal reactivation during SWS. For procedural tasks, however, on the other hand, the specific reactivation of those areas of the brain that had already been employed during the preceding training was found, as expected, specifically during REM sleep.[14]

The exact neurophysiological mechanisms that cause memory representations to be strengthened in sleep still remain largely unknown. Recent research findings, however, suggest an interaction among many different factors.[15] In the case of declarative memory formation, the slow oscillations of brain potentials characterising SWS apparently play a decisive causal role. This is confirmed by the results of a study recently carried out in our laboratory where test subjects had special electrodes attached to their heads that externally increased the slow oscillations during sleep, which as it turned out improved retention performance for previously learned lists of word pairs.[16] The intensification of EEG waves in other frequency areas than the slow oscillations, however, did not produce a similar effect promoting memory retention.

Conclusions

We really do learn in our sleep; in fact, it's natural. But this is only true in the sense that memory contents absorbed before falling asleep are consolidated while sleeping. Putting a book under your pillow before going to sleep is not enough—you have to read it first. Then, sleep really does help by actively processing what you learned!

As soon as the neurophysiological mechanisms behind the process of active memory consolidation in sleep are more thoroughly understood, it will be possible to conceive of technical applications that optimise this process and improve individual memory performance. As the last study mentioned shows, the selective enhancement of particular EEG waves during sleep is one possible approach. At the moment, such methods are highly laborious and only applicable in the context of basic research. In the future, however, this research may well also produce viable technologies for everyday use.

1 Jenkins, J G and Dallenbach, K M. "Obliviscence During Sleep and Waking", *American Journal of Psychology* 35, 1924, pp. 605–612.

2 Gais, S et al. "Early Sleep Triggers Memory for Early Visual Discrimination Skills", *Nature Neuroscience 3*, 2000, pp. 133–1339; Stickgold, R et al, "Visual Discrimination Learning Requires Sleep after Training", *Nature Neuroscience 3*, 2000, pp. 1237–1238.

3 Wagner, U et al. "Sleep inspires insight", *Nature 427*, 2004, pp. 352–355.

4 Mazzarello, P. "What Dreams May Come?", *Nature 408*, 2000, p. 523.

5 Loewi, O. "An Autobiographic Sketch", *Perspectives in Biology and Medicine 4*, 1960, pp. 3–25.

6 Fowler, M J et al. "Sleep and Memory", *Science 179*, 1973, pp. 302–304; Ekstrand, B R. "The Effect of Sleep on Human Long-term Memory", Drucker-Colin, R R and McGaugh, J L (eds). *Neurobiology of Sleep and Memory*, New York, 1977, pp. 419–438.

7 Plihal, W and Born, J. "Effects of Early and Late Nocturnal Sleep on Declarative and Procedural Memory", *Cognitive Neuroscience 9*, 1997, pp. 534–547.

8 Plihal, W and Born, J. "Effects of Early and Late Nocturnal Sleep on Priming and Spatial Memory", *Psychophysiology 36*, 1999, pp. 571–582.

9 Maquet, P et al. "Functional Neuroanatomy of Human Rapid-Eye-Movement Sleep and Dreaming," *Nature 383*, 1996, pp. 163–166.

10 Wagner, U et al. "Emotional Memory Formation is Enhanced Across Sleep Intervals with High Amounts of Rapid Eye Movement Sleep", *Learning & Memory 8*, 2001, pp. 112–119.

11 Wagner, U et al. "Brief Sleep after Learning Keeps Emotional Memories Alive for Years", *Biological Psychiatry 60*, 2006, pp. 788–790.

12 Wilson, M A and McNaughton, B L. "Reactivation of Hippocampal Ensemble Memories During Sleep", *Science 265*, 1994, pp. 676–679.

13 Peigneux, P et al. "Are Spatial Memories Strengthened in the Human Hippocampus During Slow Wave Sleep?", *Neuron 44*, 2004, pp. 535–545.

14 Maquet, P et al. "Experience-dependent Changes in Cerebral Activation During Human REM Sleep," *Nature Neuroscience 3*, 2000, pp. 831–836.

15 Born, J et al. "Sleep to Remember", *Neuroscientist 12*, 2006, pp. 410–424.

16 Marshall, L et al. "Boosting Slow Oscillations During Sleep Potentiates Memory", *Nature 444*, 2006, pp. 610–613.

William S Gilbert

from *Lolanthe*

When you're lying awake with a dismal
headache, and repose is taboo'd by anxiety,
I conceive you may use any language you choose
to indulge in, without impropriety;
For your brain is on fire—the bedclothes
conspire of usual slumber to plunder you:
First your counterpane goes, and uncovers
your toes, and your sheet slips demurely from
under you;

Then the blanketing tickles—you feel
like mixed pickles—so terribly sharp is
the pricking,
And you're hot, and you're cross, and you
tumble and toss till there's nothing 'twixt
you and the ticking.

Then the bedclothes all creep to the ground in
a heap, and you pick 'em all up in a tangle;
next your pillow resigns and politely declines
to remain at its usual angle!

Well, you get some repose in the form of a doze,
with hot eye-balls and head ever aching.
But your slumbering teems with such horrible
dreams that you'd very much better be waking;
For you dream you are crossing the Channel,
and tossing about in a steamer from Harwich—
Which is something between a large bathing
machine and a very small second-class carriage

And you're giving a treat (penny ice and cold
meat) to a party of friends and relations—
They're a ravenous horde—and they all
came on board at Sloane Square and South
Kensington Stations.
And bound on that journey you find your
attorney (who started that morning from Devon);
He's a bit undersized, and you don't feel
surprised when he tells you he's only eleven.

Well, you're driving like mad with this singular
lad (by the by, the ship's now a four-wheeler),
And you're playing round games, and he calls
you bad names when you tell him that 'ties
pay the dealer';
But this you can't stand, so you throw up your
hand, and you find you're as cold as an icicle,
In your shirt and your socks (the black silk
with gold clocks), crossing Salisbury Plain
on a bicycle:

And he and the crew are on bicycles too—
which they've somehow or other invested in—
And he's telling the tars all the particulars of a
company he's interested in—It's a scheme of
devices, to get at low prices all goods from
cough mixtures to cables
(Which tickled the sailors), by treating
retailers as though they were all vegetables—

You get a good spadesman to plant a small
tradesman (first take off his boots with a
boot-tree),
And his legs will take root, and his fingers
will shoot, and they'll blossom and bud like
a fruit-tree—
From the greengrocer tree you get grapes
and green pea, cauliflower, pineapple, and
cranberries,
While the pastrycook plant cherry brandy
will grant, apple puffs, and three corners,
and Banburys—

The shares are a penny, and ever so many are
taken by Rothschild and Baring,
And just as a few are allotted to you, you awake
with a shudder despairing—

You're a regular wreck, with a crick in your
neck, and no wonder you snore, for your
head's on the floor,
and you've needles and pins from your soles
to your shins, and your flesh is a-creep, for
your left leg's asleep,
and you've cramp in your toes, and a fly on
your nose, and some fluff in your lung, and
a feverish tongue,
and a thirst that's intense, and a general sense
that you haven't been sleeping in clover;

But the darkness has passed, and it's daylight
at last, and the night has been long—ditto,
ditto my song—and thank goodness they're
both of them over!

Jonathan Coe

from *The House of Sleep*

"It's a simple experiment, once you understand the principle. And I can't claim any credit for inventing it: like most of the great innovations in sleep research, it originated in America. Let me explain." He pointed at the healthier-looking of the two rats in the glass tank. "This rat here is the control. The other one is the test animal. When both rats are awake, the turntable is stationary. When the test animal falls asleep, the computer recognises its slower brainwaves, and the turntable is automatically activated. Both rats have to start moving, to avoid being pushed into the water. But, when the test animal is spontaneously awake, on the stationary turntable, the control animal is able to sleep, while the test animal is allowed no sleep at all."

"Until it dies, presumably."

"Precisely."

...

"I still don't quite understand", said Terry—the words coming with some difficulty now —"the role of the control animal in this experiment. Why must there be two of them?"

"That's easily explained", said Dr Dudden. "Come with me."

...

"This, as you've probably guessed, is our sleep deprivation room", said Dr Dudden. "It's where we experiment on human subjects. Not too Spartan, is it?"

"No, not at all."

"You'll notice that my priority in equipping this room has been to find ways of stimulating the subject. It's essential, you see, that he finds plenty of ways to keep his mind and body fully occupied."

"Very impressive", said Terry, absently: his eyes were drawn, as usual, to the shelf of videos, and he was busy checking out the titles.

"Superficially, yes", said Dr Dudden. "But this is really rather a primitive way of studying sleep deprivation. Do you see why? Supposing, after three days in here, the subject shows all the signs of physical exhaustion. Is that due to lack of sleep, or because he has spent too much time on the rowing-machine? His mental responses are slow and erratic. Is that due to lack of sleep, or because he has been watching eight hours of television? Do you see the problem? Is it the lack of sleep that has exhausted him, or the activities required to induce that lack of sleep?" He led Terry out of the room, and locked the door carefully behind him. "That", he said, gesturing again at the 12 glass tanks, "is the problem which this experiment so ingeniously solves. Both animals are stimulated equally, but only one of them is subjected to constant sleep deprivation. In this way, we succeed in isolating those symptoms which are the result of sleep deprivation alone."

"Yes, I can see that now", said Terry. "So all you need to find is a version of the experiment which works for human subjects."

"Correct."

Terry indicated the second door; the one which had so far remained locked.

"Are you going to show me what's in there?"

...

"Napoleon was a light sleeper, too. And Edison. You'll find it true of many great men. Edison despised sleep, we're told, and in my view he was right to do so. I despise it, too. I despise myself for needing it." He leaned closer to Terry and confided: "I'm down to four hours, you know".

"Four hours?"

"Four hours a night. I've kept it up for the last week."

"But that can't be good for you, surely. No wonder you look so tired."

"I don't care. My target's three, and I'm going to get there. It's a struggle for some of us, you know. We don't all have your gifts. That's why I envy you so much. That's why I'm determined to discover your secret."

Terry took a modest sip from his glass. "Why despise it, anyway? I don't understand."

"I'll tell you why: because the sleeper is helpless; powerless. Sleep puts even the strongest people at the mercy of the weakest and most feeble. Can you imagine what it must be like for a woman of Mrs Thatcher's fibre, her moral character, to be obliged to prostrate herself every day in that posture of abject submission? The brain disabled, the muscles inert and flaccid? It must be insupportable."

"I hadn't thought of it like that before", said Terry. "Sleep as the great leveller."

"Exactly. That's exactly what it is: the great leveller. Like fucking socialism."

Auf Zeit
Raffael Rheinsberg
1995

Installation of brass and steel
clockwork components
Property of the artist
© VG Bild-Kunst, Bonn
Photographs: Fritz Rapp, Rottweil

Raffael Rheinsberg has produced
an enormous work of art from
countless components of clocks,
cogwheels, anchors, spindles and
springs. From afar it resembles
a sparkling, endless cosmos. Close
to it suggests the impossibility of
grasping or measuring time.

1

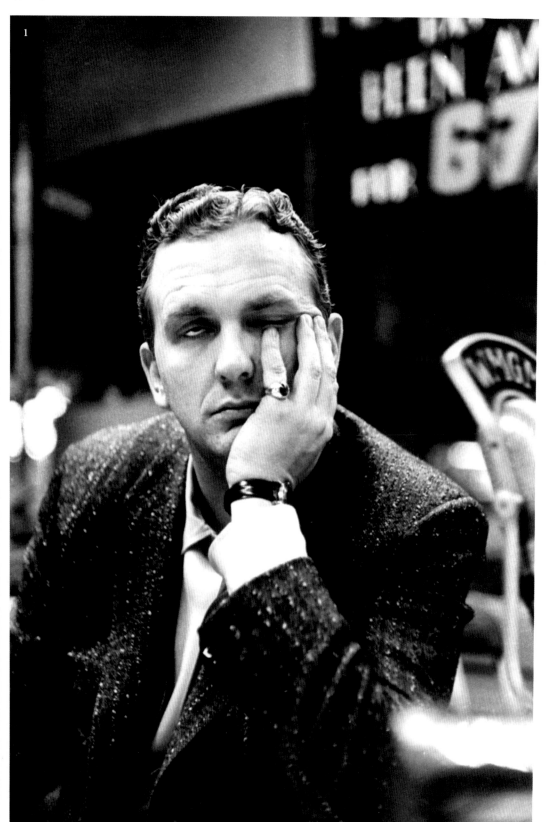

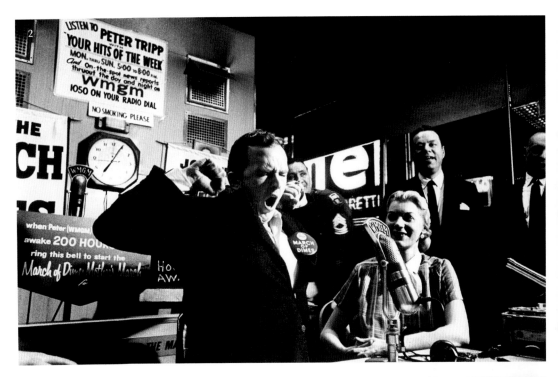

Staying Awake Record:
Peter Tripp
Ted Russell
New York 1959

Photographs:
Munich, Getty Images

In 1959, the New York disc
jockey Peter Tripp managed to
keep awake for 201 hours. His
'Wakeathon' was conducted under
constant medical supervision.
The lack of sleep changed Tripp's
disposition: he became aggressive,
hallucinated and suspected his
attendants of plotting against
him. Nonetheless, he presented his
daily broadcast almost flawlessly
from a glass container in Times
Square. After staying awake
for eight days Tripp slept for
13 hours and then felt completely
rested. However, his subsequent
professional and private problems
were interpreted as consequences
of the experiment.

1 After 67 hours without
sleeping.

2 After 199 hours and 40
minutes without sleeping.
Tripp with his wife and
attendant.

3 Reaching his goal of 200
hours without sleeping.

Overleaf
After 80 hours without
sleeping.

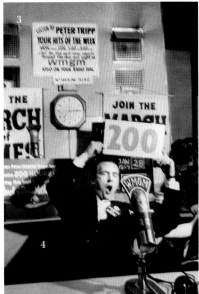

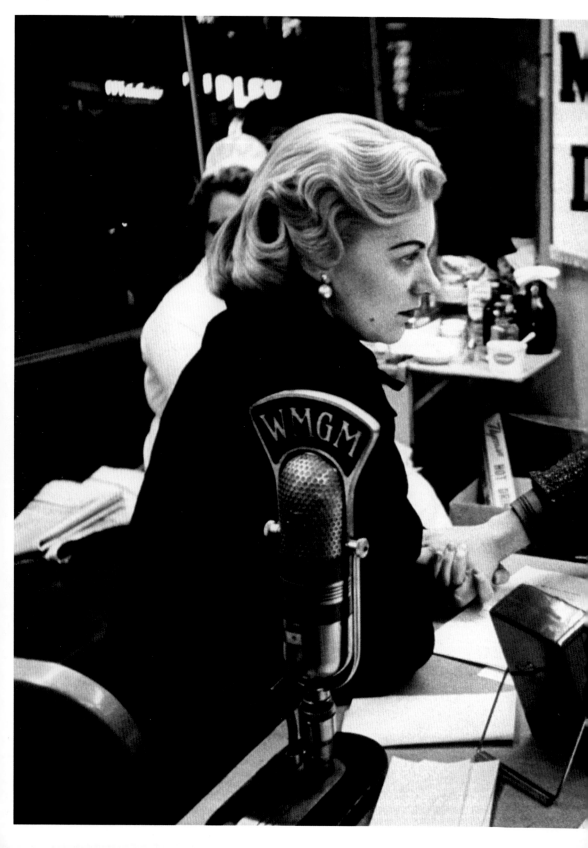

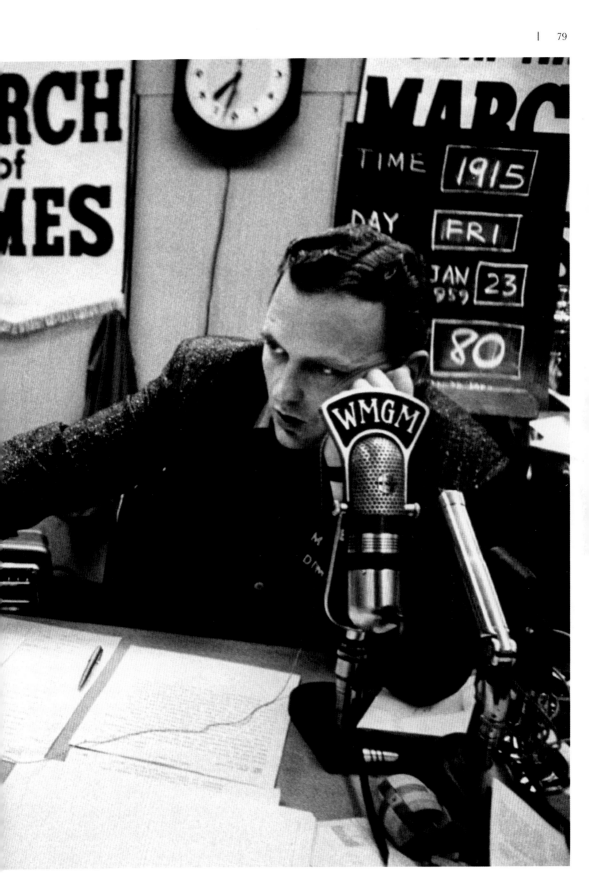

Staying Awake Record:
Randy Gardner
Bob Redding
San Diego 1964

Photographs:
San Diego, San Diego
Historical Society

Stay awake! The student Randy
Gardner, supported by his friends
Joe Marciano and Bruce McAllister,
wanted to break the record: an
unusual experiment at the turn of the
year 1963 for the San Diego Science
Fair. Going for a drive by night,
playing pinball machines, flying
visits to the beach, police stations and
prisons and various tests of his
reactions and performance kept
Gardner awake. After 264 hours he
finally gave up and went to bed. He
answered the question as to how he
had achieved this feat, saying "It's
just mind over matter". From the
seventh day onwards the renowned
sleep researcher William Dement
attended the project.

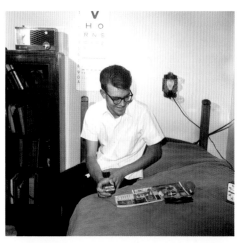

Detail from
Allegorical Depiction of an Operation Under Narcosis
Richard Tennant Cooper
c 1912

Watercolour, gouache, pencil
Wellcome Library, London

Collapse in the Night:
Processing Traumatic Dream Experiences

Tamara Fischmann

Trauma: it means injury, wound. However the definition of the word and the concept it commonly refers to differ. For when we speak of psychological trauma we are not generally referring to a threatening or disturbing occurrence itself, but rather the psychic damage that results from such an occurrence. A trauma is a lesion inflicted on an individual's emotional or psychological integrity by a deeply unsettling event.

Signs of Traumatisation

The effects of a trauma usually reveal themselves in the form of post-traumatic stress disorder. This is defined according to the International Statistical Classification of Diseases and Related Health Problems (ICD–10 2005) as a "delayed or protracted response to a stressful event or situation (of either brief or long duration) of an exceptionally threatening or catastrophic nature, which is likely to cause pervasive distress in almost anyone". The classification goes on to say that:

Predisposing factors, such as personality traits (eg, compulsive or asthenic tendencies) or previous history of neurotic illness, may lower the threshold for the development of the syndrome or aggravate its course, but they are neither necessary nor sufficient to explain its occurrence. Typical features include episodes of repeated reliving of the relevant trauma in intrusive memories ('flashbacks'), dreams or nightmares, generally occurring against the background of a sense of 'numbness' and emotional blunting.

Sigmund Freud initially proceeded on the assumption that anxiety is the original reaction to the helplessness experienced during trauma, leading him to argue—in his 1920 study "Beyond the Pleasure Principle"—that the lack of an anxiety reaction is the precondition for traumatisation in traumatic neurosis. By 1939, Freud had revised his theory, no longer referring to anxiety as the immediate reaction to trauma, but rather stating that the mind responds to traumatic experiences with fear in the first instance, and further outlining other phenomenological symptoms including paralysis, stupor or shock. Freud thus defines trauma as the helplessness experienced due to an excessive stimulation that cannot be reduced, and defines danger as the expectation of this kind of helplessness.

The experience of sleep trauma must be examined from a different perspective. The manifest dream—the dream reported after waking—cannot, according to Freud, contain anything more than the content of the latent dream. Similarly, Freud held the view that dream work only draws on what already existed prior to falling asleep, and that the manifest dream can never contain anything more than what had already been given representation in the psyche before the dream work began. However, if we take the dreams of Dr Hilprecht and Kekulé as examples, Freud's assertions begin to seem outdated.[1] In these two cases, what appears to be happening is something quite different from Freud's predictions, in that existing psychic elements are not simply being reorganised in the dream work, but rather, totally original associations are being made between existing elements, infusing them with altogether new meanings. If we are persuaded by these cases, one can conclude that the dream serves a variety of functions, a view supported by a several sources including Sándor Ferenczi, a range of experimental dream research and Freud himself.[2]

According to Freud, the anxiety dreams of patients suffering from traumatic neurosis serve to reduce the effects of the trauma, and thus act as a stepping-stone to recovery. Like Freud, Ferenczi also maintained that the dream state has a traumatological function, allowing the mind to process psychological disturbance with greater effect. Yet many dreams do not actually succeed in reducing anxiety, and as a result, anxiety dreams and nightmares occur. The nightmare is typified by the dreamer's prolonged state of anxious paralysis.

Findings from experimental studies on dreams overwhelmingly indicate that the majority of pathological manifestations in sleep—sleepwalking, teeth grinding, talking, bedwetting, terror disorder (*pavor nocturnus*)—are not associated with dream activity if dreaming is exclusively defined as mental activity during REM sleep.[3] Rather, these pathological manifestations generally occur during non-REM (NREM) sleep phases, for example,

Milan Kundera

from *Slowness* (trans Linda Asher)

Véra is sleeping, and I, standing at the open window, I am watching two people strolling in the château's park by the light of the moon.

Suddenly I hear Véra's breathing grow rapid, I turn towards her bed and I realise that in another moment she will start to scream. I've never known her to have nightmares! What goes on in this château?

I wake her and she stares at me, her eyes wide, full of fear. Then she speaks, pell mell, as if in a fit of fever: "I was in a very long corridor in this hotel. All of a sudden, from far off, a man appeared and ran towards me. When he got within ten metres, he started to shout…. Then he came a few steps from me, threatening, and that's when you woke me up".

"Forgive me", I say, "you're the victim of my crazy imagination".

"How do you mean?"

"As if your dreams are a wastebasket where I toss pages that are too stupid."

bedwetting, sleepwalking and sleep terrors occur during sudden arousals
in sleep stages three and four, or what is commonly referred to as slow wave
sleep. These sleep pathologies are often accompanied by mental confusion,
disorientation, autonomous reactions, relatively limited reaction to external
stimuli, reduced response to attempts at awakening, retrograde amnesia, and
only fragmentary dream memories.

The Mechanism of Anxiety Dreams

Based on these findings, one must distinguish among different types of dreams:

1. Nightmares in stage two sleep (with less intensely experienced anxiety).

2. Anxiety dreams in REM sleep (which are experienced subjectively as nightmares).

3. Nightmares in stage four sleep (including sleep terrors).

The findings from experimental studies on the psychophysiology of
nightmares have led to the conclusion that stage four nightmares are usually
preceded by loud cries for help and accompanied by uncontrolled anxiety
reactions. They almost always occur during the first two NREM phases, in
the first hours of sleep. An arousal reaction follows the cry, leaving the sleeper
with a disassociated sensation, though he or she does not generally react to the
environment, oftentimes experiencing hallucinations. Though not actually
awake, the brainwave pattern of aroused stage four sleepers resembles the
alpha pattern of the waking state. Many stage four nightmares are also
accompanied by sleepwalking; the heart rate doubles and respiration is
accelerated. It is striking to note that shortly before the start of the nightmare,
all of the physiological reactions mentioned are normal, it is only when the
nightmare begins that the sleeper's physical processes accelerate suddenly and
without warning. The delta waves measured in sleep stage four (a sign of sleep
depth) are also closely connected to the intensity of the nightmare: the deeper

Edmund Spenser

from "The Faerie Queen"

**Is not short paine well borne, that brings long ease,
And layes the soule to sleepe in quiet grave?
Sleep after toyle, port after stormy seas,
Ease after warre, death after life does greatly please.**

the sleep, the more intensely the nightmare is experienced. One puzzling finding, however, is that those test subjects who suffer nightmares during sleep stage four actually sleep very calmly and peacefully during the REM stage.

Experimental dream research indicates that nightmares occurring during REM sleep are experienced with the greatest anxiety. In contrast to the nightmares in sleep stage four, sleepers show changes in the physiological parameters (heart frequency, breathing, etc) before spontaneous awakening, with the nightmare announcing itself in advance of its actual occurrence. Little can be said about the content of stage four nightmares, since they are usually forgotten immediately. If their contents are reported at all, it is usually just senses or particular scenes—for example, the fear of suffocation, of darkness, of being alone, of falling or of being crushed. These incomplete accounts present a stark contrast to the highly elaborate REM dream reports, where the contents are coherent, psychodynamically organised, and oftentimes related to the sleeper's existing trauma and conflicts.

What conditions lead to the emergence of stage four nightmares? One would expect to find an increased occurrence of stage four nightmares in traumatised individuals, as these occurrences appear to be a more serious pathological phenomenon than REM anxiety dreams. But in a study of individuals who often suffer from nightmares, this was true for only two per cent of the survey population. While most nightmares occur during REM sleep phases, the factor for the occurrence of stage four nightmares is preceding sleep depth (delta sleep), which is accompanied by increased ego regression. The fact that neither accelerated breathing nor tachycardia are observed prior to the nightmare reaction suggests that what is actually occurring is a massive, violent eruption of either repressed fear from past traumatic experiences or regressively reactivated traumatic fixations. Endogenous contents are probably not adequate to trigger such reactions, such that the existence of more distant, exogenous stimuli must be assumed. The finding that test subjects with severe nightmares in stage four show a much lower arousal threshold during this stage than during REM sleep —whereas healthy sleepers show precisely the opposite—supports this thesis. These nightmares may be triggered by such exogenous stimuli as the noise of an airplane or physical discomfort.[4] REM dreams present a stark contrast to stage four nightmares, and the changes in physiological parameters observed during the former are in no way comparable to those observed during the latter. REM dream reports often have a high anxiety content but without any spontaneous arousal reaction, leading to the conclusion that REM sleeping contains an inherent mechanism that mitigates and modulates anxiety. This device seems to desomatise the physiological reactions to dreams, reducing or eliminating the accompanying physiological symptoms. Such mechanisms help to sustain sleep even when the sleeper is having an anxiety dream, leading some commentators to dub the REM stage the true guardian of sleep.

The Bible

from Proverbs XXIII

Drowsiness shall clothe a man with rags.

In summary, it can be stated that stage four nightmares deal with uncontrolled anxiety and that REM dreams deal with controlled anxiety. REM anxiety dreams that cause the sleeper to wake up suddenly are rooted in complex, prolonged dream episodes that last approximately 20 minutes. NREM nightmares that cause the sleeper to wake up, on the other hand, are sudden, overwhelming events connected to an individual scene that appears simultaneously with the arousal reaction. The suddenness and lack of preparation appear to be linked to the force of the autonomous reactions and uncontrolled anxiety. Freud already pointed out that the unpreparedness for danger increases the force of the anxiety reaction.

The findings from experimental dream research suggests that stage four nightmares do not support the Freudian theory of death, nor do they operate beyond the pleasure principle, driven by the compulsion to repeat.[5] In the best case scenario, stage four nightmares may be referred to as a symptom, a pathological 'bandage' of NREM sleep to quell a rupture in the ego's capacity to control anxiety. The stage four nightmare thus appears to resemble a brief and reversible psychotic attack rather than a dream.

The Primary Dialogue

To understand traumatic experiences and their effects, one must bear in mind that such experiences occur against the backdrop of prior experience. They result from the child's experiences with his environment and take place through a 'primary dialogue' with this environment.[6] This dialogue is at first mystifying to the child, who is still in the process of trying to understand the seemingly opaque adult world, using this dialogue to determine what the world wants from him or her. The dialogue is carried out mainly through the relationship to a primary object, and constitutes the psychological work of rearticulating a confusing reality into a psychological language the child can understand. The pleasure principle therefore plays a dual role here: satisfying wishes and imparting meaning to the world. However uncomfortable, adult thinking is only possible through the unavoidable frustrations that we experience as children, which—according to Freud—involves everything from hallucinating and dreaming, to gameplay and fantasising. In this internalised 'primary dialogue', a process can be identified that provides

the psychic basis for coping with contradictory demands. It thus forms the condition for being able to maintain a belief while simultaneously being aware that it is an illusion. This process thus comes extremely close to the concept of 'mentalisation'.[7] That is, the child develops the capacity to give account for his own and others' mental states. If this inner dialogue is destroyed—by a trauma for example—there are unavoidable consequences, and these affect our dream life as well.

Dream Work and its Limits

According to James L Fosshage, dream work provides a framework for the wishes we develop through perceptions and affective impressions, and allows us to work through the conflicts activated by such emerging wishes.[8] This work is carried out through dream images, which represent a language that helps us to express and gain access to affects and ambiguous impressions drawn from the day. As such, dream work is a kind of thinking that articulates the inaccessible, and thus forms the visible part of a continuous inner dialogue. Dream work is ultimately symbolisation aimed at recreating and maintaining psychic reality.[9] In order for it to be carried out, the facts of external reality must not become too intrusive so as not to divert too much attention from the inner world.

If dreaming is the activity of inner psychic reality, the reflection of our conscious and unconscious experiences, then sleep is an escape that protects us from the insistent demands of our everyday life. It offers us the possibility to curl up in a fetal position under the protective shield of sleep, pull the blanket up over our heads and abandon ourselves to the illusion of primary experience. In this way, we can establish an original connection to the primary object so that psychic repair work can be carried out.

John Fletcher

"Sleep"

Come, Sleep, and with thy sweet deceiving
Lock me in delight awhile;
Let some pleasing dreams beguile
All my fancies; that from thence
I may feel an influence
All my powers of care bereaving!

Though but a shadow, but a sliding,
Let me know some little joy!
We that suffer long annoy
Are contented with a thought
Through an idle fancy wrought:
O let my joys have some abiding!

The dual goal of dream work is seen in the compromises it achieves. It enables us to process psychological reality so that our everyday becomes bearable. Its basis in the pleasure principle protects us from the reality that has the potential of robbing our life of meaning. For this reason, we paint the triviality of everyday life in the colours of hopes for infantile wish fulfillment, and it is precisely these timeless unconscious desires (drives) that transform everyday life into something meaningful. In dreams, we see the inner world's wishes fulfilled in a convincing and satisfying way, forming the foundation for our belief in a timeless psychic reality.[10] Through the timelessness of the dream, the inexorable weight of time in reality is brought back into psychological balance.

If the trauma represents a situation in which one cannot wish, then it constitutes a phenomenon that transcends the pleasure principle. In the refuge of sleep, we try to work through and symbolise conflicts, but for the symbolisation to be effective it must be protected from an excess of anxiety-laden material. This is done through further repression and other instrumental tendencies, and in the best case scenario, the dream succeeds in reaching its goal of wish fulfillment and infusing meaning into our waking life. Repression is characterised by its unchanging nature over time and periodic recurrence —for example, in dreams. If the repressed material returns in dreams, fantasies, and narratives, it is constantly infused with new meaning, while infantile wishes are experienced as an eternal present, shaping the narrative in which different temporal dimensions are portrayed. This normal, healthy process is interrupted in the case of traumatic experiences, which cannot be symbolised and remain unchanged over the course of the dream work.

Traumatic experiences therefore lead to the failure of the dream work, as Freud demonstrated in 1933. Our objective here is to understand why this is the case. When affected individuals approach their traumatic experiences, they relive the horror and fear that follows from the immediate psychic threat, terrified that their inner world is on the verge of exploding and their entire existence in danger of being destroyed. The dream constitutes an attempt to stall these painful effects while the psyche is searching for a place where it can understand what it was that once threatened its existence. Through dreams and fantasies it becomes possible to turn to the past in order to recognise images that make comprehension of the future possible, usually through transferal to an object that acts as a representation of this past. These kinds of dreams represent both a rearticulation of an individual's previous experience, and a totally unique experience relevant to the here and now of inner life.[11] Dreaming is a kind of psychological work that strives for transformation, it aims at allowing the individual to let go of something from the past that blocked thoughts revolving around a threatening experience.

If the integrity of psychic reality can no longer be protected, existence can no longer be symbolised or dreamed, destroying representation and making it

unavailable to reflection. The only option that remains open to the psyche is to deny the entire experience and all of its implications, with all psychic energy mobilised in this direction to avoid the terror that threatens the integrity of the inner world. If pain and nameless horror continue endlessly, our sense of time becomes an infinite torture, and psychological non-recognition provides the only relief to the sufferer. Dreams and fantasies no longer exist, the inner dialogue has fallen silent since it offers no further hope and the individual becomes alienated from experience. Could it be that nightmares and the repetition compulsion spring from this source?

Non-recognition corresponds to the thought without a thinker. According to A Green (whose arguments follow those of W R Bion) thoughts emerge that cannot be thought since there is no thinking apparatus capable of processing or elaborating them.[12] Because such thoughts cannot even be formalised in the mind of the thinker, they cannot be communicated to others, and there is therefore no avenue for them to be psychologically processed. Green differentiates between psychological events stemming from the body—understood as thoughts without thinkers—and thoughts produced by a thinker, which can be conveyed to others. In his *Holocaust Testimonies* Lawrence Langer describes how survivors of concentration camps find it impossible to integrate their experiences into narrative frameworks of the past, living with the constant feeling that their story is unbearable for outsiders. They therefore report that their memories of events 55 years ago become ever more confused and blurred over time, while the images of concentration camps that appear to them in the night are of such appalling clarity as to rip them out of sleep. The nightmares are recurring, but rather than dreaming, the traumatised individual awakens from the raw, inaccessible reality of the past that plagues him. In the daytime, these affects are denied and the memories repressed. Recognition of these traumatic symptoms—which would have illuminated the path toward a way of thinking that could have rendered the past experiences meaningful—has been extinguished. In the night, when sleep shuts out reality and the protection

Thomas de Quincey

from "Dreaming"

He whose talk is of oxen will probably dream of oxen; and the condition of human life which yokes so vast a majority to a daily experience incompatible with such elevation of thought oftentimes neutralises the tone of grandeur in the reproductive faculty of dreaming. Habitually, to dream magnificently, a man must have a constitutional determination of reverie.

against returning images is weakened, these all-too-clear scenes take control and the concrete everyday loses its dominance over the traumatic event. These images cannot be called dreams but rather useless attempts at dream. To put it in different terms, they are efforts at integrating experiences into psychic reality in the hope that by processing an unbearable reality, the dream will create distance from it in space and time. This effort usually fails due to the impossibility of integrating this specific past event into the individual's personal history, of historicising it.

If the primary object had been present, the subject would not have been delivered up to this traumatising experience. For this reason, the subject's basic trust in the primary object has been shattered. As a result, desire —the real source for meaningful narratives—has been destroyed, and with it the space for psychological connections. The need to share personal experiences has run dry. The collapse of the inner dialogue—a lost capacity to symbolise—reveals itself in a state of speechlessness about oneself and one's environment. Dreaming too—as palliative experience—becomes impossible, leading to a psychological collapse in the night.

1 (see J F Danckwardt, "Farben im Traum. Ein Beitrag zur Traumdeutung Sigmund Freuds", in *Forum der Psychoanalyse 22*, 2, pp.165–181, see also D Perkins, *Geistesblitze: Innovatives Denken lernen mit Archimedes*, Einstein und Co, Frankfurt/M 2001.

2 "Notes and Fragments [1930–1932]", *The International Journal of Psychoanalysis 30*, 1949, pp. 231–242.

3 Fisher, C et al, "A Psychological Study of Nightmares", *Journal of the American Psychoanalytical Association, 18*, 1970, 747–782 and Greenberg, R et al "A Research-Based Reconsideration of the Psychoanalytic Theory of Dreaming", *Journal of the American Psychoanalytical Association, 40*, 1992, pp. 531–550.

4 Krystal, H and Niederland, W G. "Clinical Observations on the Survivor Syndrome", Krystal, H (ed), *Massive Psychic Trauma*, New York, 1968.

5 Schur, M. *The Id and the Regulary Principles of Mental Functioning*, New York 1966.

6 Künstlicher, R. "Human Time and Dreaming", *Scandinavian Psychoanalytic Review 24*, 2001, p. 75–82.

7 Fonagys, P. "Thinking about Thinking: some Clinical and Theoretical Considerations in the Treatment of a Borderline Patient", *The International Journal of Psychoanalysis 72*, 1991, pp. 639–656.

8 "The Organising Function of Dream Mentation", *Contemporary Psychoanalysis 33*, 1997, pp. 429–458.

9 see D Anzieu, *The Skin Ego*, New Haven and London 1989.

10 Green, A. "Temporality in Psychoanalysis. Exploded Time" Presented at the Standing Conference on Psychoanalytical Intracultural and Intercultural Dialogue in Paris, July 1998.

11 Modell, A. *Other Times, Other Realities*, Cambridge, Massachusetts and London, 1990.

12 "The Primordial Mind and the Work of the Negative", *The International Journal of Psychoanalysis 79*, 1998, 649–665, "A Theory of Thinking", *The International Journal of Psychoanalysis 30*, 1962, pp. 165–181.

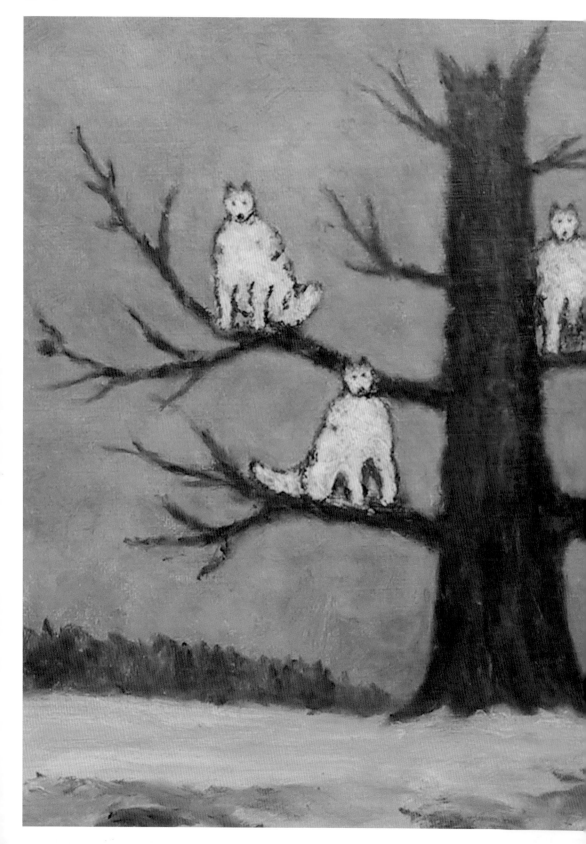

My Dream
Sergei Pankejeff
1964

Oil on canvas
The Freud Museum, London

When he was four years old, the 'Wolf Man', Sergei Pankejeff, had dreamed that the window of his bedroom opened by itself to show six or seven white wolves sitting motionless in a tree, wanting to eat him. By studying the associations that the 'Wolf Man' built up during his therapy, Freud reached the conclusion that the dream reflected a 'primal scene' witnessed by the patient, of his parents having sexual intercourse. Many years later Pankejeff recorded his famous dream in an oil painting.

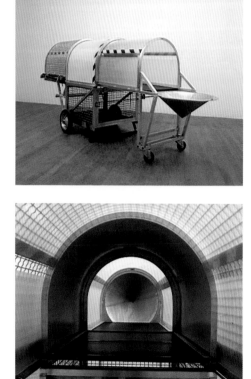

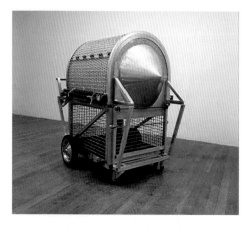

Homeless Vehicle
Krzysztof Wodiczko
1988–1993

Aluminium, Plexiglass, clingfilm,
adhesive tape, string, rubber, steel
Lyon, Collection du Musée d'Art
Contemporain de Lyon, France

Photographs left: © Blaise Adilon
Photograph below: © Krzysztof Wodiczko
Courtesy of Galerie Lelong, New York

In discussion with the homeless
of New York, Krzysztof Wodiczko
developed the *Homeless Vehicle*:
a bed on wheels; a transport and
storage facility; a 'dream house'
for the nomads of modern cities.

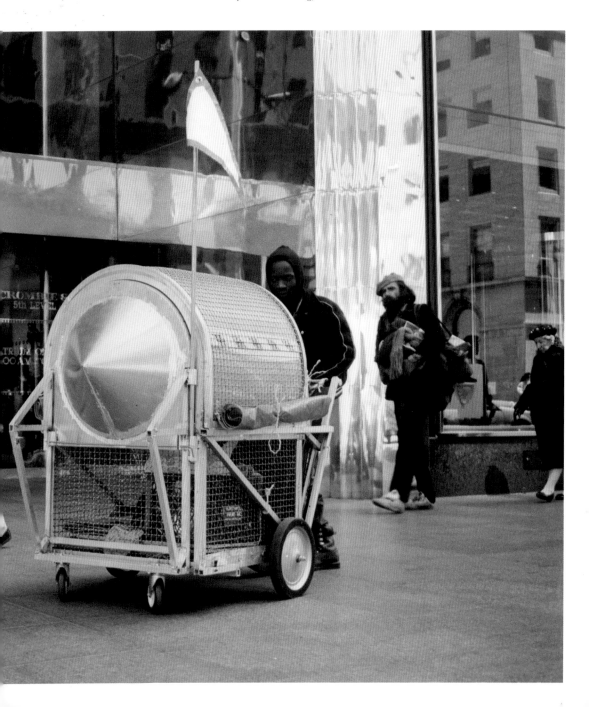

Glucose Consumption by the Brain During Wakefulness, Deep Sleep and REM Sleep
Pierre Maquet et al
1989

PET-Scans
University of Liège

Brain activity can be established by measuring glucose consumption. This is determined and pictured through Positron Emission Tomography (PET). A high glucose consumption is shown in red, a low one in blue. Wakeful and REM phases consume a great deal of glucose. In deep sleep a clearly reduced level of brain activity can be recognised.

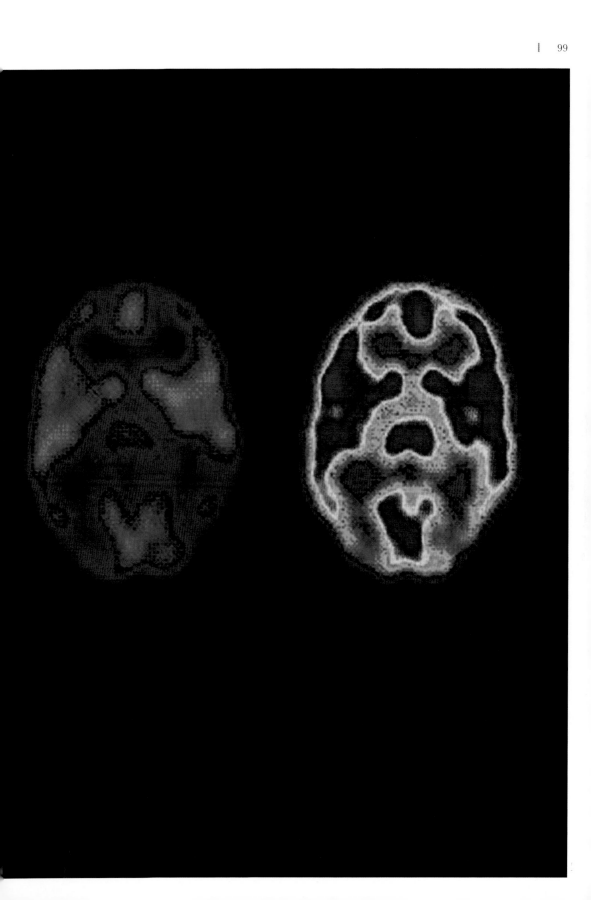

Detail from
Man and Mouse
Katharina Fritsch
1991–1992

Dreams in Contemporary Psychoanalysis

Daniel Pick[1]

The interpretation of dreams, Freud famously insisted, provides the 'royal road' to the discovery of unconscious psychic life. The characteristic manner of considering the night-life of the mind inside psychoanalytic consulting rooms has shifted markedly over the last century, but is dream interpretation still the 'royal road'? Some psychoanalysts clearly privilege such content over other material, and use dreams to structure clinical papers—what better way than through the selection of a telling example and the unfolding story of its interpretation? But psychoanalysts today tend to be more alert than in the past to ways in which patients use dreams, alongside other communications, unconsciously, in sessions. These days, the interpretation of dreams is inextricably bound up with consideration of the transference.[2]

Summarising—as I do here—a general, contemporary approach to dreams in clinical practice requires the attachment of a health warning, for the psychoanalytic movement is a loose term referring to an extremely varied set of approaches. There are too many schools of thought, national traditions and subdivisions, conflicting techniques and models to enable neat outlines of current practice. The movement has both centrifugal and centripetal tendencies, a variety of regional orthodoxies and debates, each of which evolves in relation to divergent intellectual and clinical developments of psychoanalysis, for instance in North and South America, France or Britain. Thus no thumbnail sketch can do justice to that complexity. Nonetheless, it has become widely assumed, and in a way increasingly obvious, that the process of imparting dreams may itself be heavily loaded with meaning for either or both parties, the dream-giver and the receiver, the patient and the analyst.

To take an obvious example, the analyst who moves expectantly in the chair as a patient brings a nightmare might inadvertently encourage the provision of such material as 'gift', or its withholding as a form of punishment and deprivation. If we think of a state of 'evenly suspended attention' as an ideal

analytic stance, then excessive zeal for dreams would indeed be a transgression of that stance. How far a patient accurately picks up such unwitting 'clues' will vary greatly. In any event, evidence (real or imagined) of the analyst's particular personal appetites or distastes may have complex and unforeseen consequences. If the analyst is (or is believed to be) primarily interested in the dream work, the patient could feel (consciously or unconsciously) neglected and let down, as though the analysis now proceeds at the expense of the person. Yet of course the patient's underlying attitude to the proffering of dreams in psychoanalysis may at that precise moment or in general be a significant issue, regardless of the practitioner's success or failure in maintaining the analytic position. Either way, the mood that surrounds the bringing of dreams merits consideration alongside the actual 'oneiric' material.

One reason we now give extra significance to dreams is because they are seen to contain features of an unconscious 'drama' that will also manifest itself in the analysis. Each provides a potential perspective on the other. Aspects of that drama may even be played out in the very session in which the dream is told, with the analyst, as mentioned, taking on, or being assigned, a part. To put this another way, the patient might unconsciously instigate a particular kind of interaction, into which the analyst is also then unconsciously drawn. Sometimes it turns out that the dream beautifully anticipates (or at least gives a supporting picture of) the state of affairs in the analysis, and vice versa.

Such 'enactments', if they do occur, are hopefully subtle rather than gross in form, with the analyst having the wherewithal to notice what is happening, or at least what has happened. Therapeutic benefit may be achieved precisely where such a 'pull' is recognised and considered—made 'food for thought'. Any number of internal obstacles to such recognition and 'digestion', in either or both parties may be present. Nonetheless, if there is some tolerance of that less than perfect situation, including within it the analyst's own inevitable partial failure to maintain an entirely consistent analytic role, this can often be helpful. Thus we strive to catch and stop ourselves becoming (through a different tone of voice or unusual gesture), a reassuring comforter, hostile critic or collusive 'friend'. We try then to think about this process, asking in what way we have found ourselves 'pulled' one way or another, and how far—if at all—the patient unconsciously played a part in bringing about that situation.

Consider, for instance, a patient prone both to intellectualising and to a 'stiff upper lip' approach to life. He brings to his male analyst's attention a dream about himself as a very young child, accompanying

his father to a museum. They get entirely lost in dimly lit galleries full of the most fascinating curios. They stay there until closing time, whereupon the father is shocked to realise that the child had been wet for ages, is cold and hungry, and that neither had apparently noticed this sorry condition as they walked around the exhibits. Having recounted the dream, the patient then immediately busies himself conscientiously with some intriguing 'historical' associations. Meanwhile the analyst becomes absorbed in listening to the curious aspects of this back history, before noticing the fast elapsing time, at which point he is finally able to point out to the patient the risk that the very process told in the dream is actually happening in the room. In other words dreams may be relived, may even foretell, something of the dynamics in the very session of which they are a part and to which they are a clue. A situation arises here in which the patient is again at risk of being left hungry, neglected and cold whilst he and the analyst/father are otherwise engaged, amidst the exhibits.

Although Freud himself sometimes generalised about dream symbols, the crucial direction of his work was against the idea—prevalent in some nineteenth-century dream books—that particular motifs or stories signified something fixed and given, regardless of the dreamer. His position was that psychoanalytic interpretations of dreams could never be exhausted, nor their theory petrified once and for all. Knowledge of dreams required continuing elaboration and revision.[3] At the same time Freud consistently argued that the 'manifest dream' was but the place from which you began the work, the moving backwards, towards the latent thoughts. His account made extraordinary use of concepts such as condensation and displacement; he saw the dream as a compromise formation in the face of an internal censor, a 'text' that bares witness both to unconscious wishes and to their repression.

Rather than thinking of this key Freudian principle merely as the fact that there is 'content' behind the immediate form, a 'secret' revealed through analysis, what most disturbs us is that a process—the unconscious—is disclosed in and through the bizarre transpositions themselves.

Joseph Heller

from *Catch-22*

Captain Flume slept like a log most nights and merely DREAMED he was awake. So convincing were these dreams of lying awake that he awoke from them each morning in complete exhaustion and fell right back to sleep.

The dream is 'worked over' from the unconscious. The unconscious is evident in such radical transformation. Something cuts across and between the manifest and latent thoughts that cannot be accounted for merely by returning to the forgotten 'latent' thought. Freud made this point in a footnote added to a later edition of *The Interpretation of Dreams* in 1925: "At bottom, dreams are nothing other than a particular form of thinking, made possible by the conditions of the state of sleep. It is the dream-work which creates that form, and it alone is the essence of dreaming—the explanation of its peculiar nature".[4]

We are strangers to ourselves in our dreams, and yet the dream is also irreducibly particular to the dreamer. That dream interpretation depends upon—and is only meaningful through—its associations, and the whole clinical context of the particular patient remains the touchstone. Even very short dreams, in Freud's great book, inevitably generated lengthy analysis, since they were never simply decodable into easily anticipated 'universal' meanings. And yet many of those who read and 'championed' *The Interpretation of Dreams*, perhaps most especially in the early twentieth century, fell back on an older 'dream book' tradition, pursuing 'wild' interpretations, wrapping up the meaning then and there. In fact, according to Freud's own lights, not even the proverbial dream of a train passing into a tunnel should be 'read off' in advance, assigned the same predictable sexual connotation for every dreamer.

Haruki Murakami

from *A Wild Sheep Chase*
(trans Alfred Birnbaum)

How many times did I dream of catching a train at night? Always the same dream. A nightliner stuffy with cigarette smoke and toilet stink. So crowded there was hardly standing room. The seats all caked with vomit. It was all I could do to get up and leave the train at the station. But it was not a station at all. Only an open field, with not a house light anywhere. No stationmaster, no clock, no timetable, no nothing—so went the dream.

I still remember that eerie afternoon. The 25th of November. Gingko leaves brought down by heavy rains had turned the footpaths into dry riverbeds of gold. She and I were out for a walk, hands in our pockets. Not a sound to be heard except for the crunch of the leaves under our feet and the piercing cries of the birds.

"Just what is it you're brooding over?" she blurted out all of a sudden.

"Nothing really", I said.

She kept walking a bit before sitting down by the side of the path and taking a drag on her cigarette.

"You always have bad dreams?"

"I often have bad dreams. Generally, trauma about vending machines eating my change."

She laughed and put her hand on my knee, but then took it away again.

"You don't want to talk about it, do you?"

"Not today. I'm having trouble talking."

With the work of Melanie Klein and her circle in inter-war Britain, came a particular emphasis on the view that unconscious phantasy was continually in operation, always shadowing and partially shaping communication. Susan Isaacs, in a now famous contribution of the 1940s emphasised the ubiquity of unconscious phantasy (spelled by psychoanalysts with a 'ph' to emphasis this quality) This paper, whilst setting out a Kleinian viewpoint, also highlighted a feature already contained in Freud's own thought. Unconscious phantasy, she insisted, was "fully active in the normal, no less than in the neurotic mind".[5] She went on to describe the analytic task thus:

> *The analyst notes the patient's manner and behaviour as he enters and leaves the room, as he greets the analyst or parts from him, and while he is on the couch; including every detail of gesture or tone of voice, pace of speaking, and variations in this, idiosyncratic routine or particular changes in mode of expression, changes of mood, every sign of affect or denial of affect, in their particular nature and intensity and their precise associative context. These, and many other such kinds of detail, taken as a context to the patient's dreams and associations, help to reveal his unconscious phantasies, among other mental facts. The particular situation in the internal life of the patient at the moment gradually becomes clear, as does the relation of his immediate problem to earlier situations.[6]*

All of this can be explored in an analysis with or without the recounting of dreams as such, but can also enrich the way in which they are heard. Perhaps today most of us are less exercised than Freud had been about systematically working through each and every facet of the dream. It might in a given session be just one detail that seems most salient and the manifest as well as the latent content may be found significant—some dreams seem to be more 'disguised' than others. But there are also dangers in this looser use of the manifest dream, shorn of Freud's laborious 'decipherings'. It can be hard to gauge, when an analyst homes in on some detail of a dream text (or even of the analysand's affect in recounting it) whether we are in the presence of an 'overvalued idea' or of a telling 'selected fact' about the patient.[7]

Admittedly even Freud's more detective-like method in working backwards from the dream was also open to the criticism that the particular route of association was arbitrary, the method unfalsifiable and potentially whimsical, but critics of the Freudian approach to dreams have often underestimated the patient's own active contribution to the forming of interpretation, and its evaluation. Critics who equate psychoanalysis with hypnosis would presumably

also see patients' reports of the moving or troubling experience of psychoanalytic understanding of dreams as a form of suggestion or manipulation. While this is quite possible, and has been the subject of continuing theoretical debate and part of the enduring 'problematic' of psychoanalysis from the very start of its history—there is much more to the story of the interpretation of dreams, or the potential mutative effects of psychoanalysis, than that.[8] Those of us who have experienced this first hand, as patients and as analysts, may choose to respond that 'the proof of the pudding is in the eating', but sceptics will probably not be satisfied with such a retort, nor by the disclaimer that patients are rarely just the plaything of the analyst's interpretative zeal or hermeneutic whim. Nonetheless, room for doubt often remains, as to whose desire is operative at a given moment, the patient's or the analyst's. Neither party, of course, is a psychological monolith. We think in terms of 'parts', 'agencies', 'objects', 'organisations' within the mind, and of continuing 'projections' into and 'introjections' of the other. So how we locate desires and anxieties is always a complex intra-psychic as well as an inter-personal matter. Proper psychoanalytic consideration of that complexity will always require fine grain evidence of sessions, rather than oracular announcements about dreams, still less general pronouncements about a patient's 'character'. As the French psychoanalyst, J B Pontalis puts it: "it is not the dream's contents but the subject's 'use' of it that reveals his true pathology".[9]

In psychoanalysis, the use of the dream is to be understood as part of a transference situation. Transference, like countertransference, once seen as obstacles to analysis, even failures of analysis, are now seen as important instruments within the 'talking cure'. The psychoanalyst Hanna Segal also

Michel de Montaigne

from *The Essays*, "On Sleep"
(trans M A Screech)

Reason ordains that we should keep to the same road but not to the same rate; and although the wise man must never allow his human passions to make him stray from the right path, he may without prejudice to his duty certainly quicken or lessen his speed, though never plant himself down like some fixed and impassive Colossus. If Virtue herself were incarnate I believe that even her pulse would beat faster when attacking the foe than when attacking a dinner—indeed it is necessary that she should be moved and inflamed. That is why I have noted as something quite rare the sight of great persons who remain so utterly unmoved when engaged in high enterprises and in affairs of some moment that they do not even cut short their sleep.

makes this point about the need to grasp the unconscious function of dreams in situ, and she underlines the transformation that has occurred in attitudes to dreams and to technique since Freud's original discovery that our repressed unconscious expresses itself in dreams:

> *Nowadays, when we understand much more about the importance of the transference and the developing relationship between the patient and the analyst, we are also concerned with the function of the dream. Why does the patient have this dream and tell it to us in a particular way at a particular time? In that way the dream is treated like any other material. The other thing that has happened since Freud is that we differentiate much more between the time and type of dream, and we consider what dynamic psychic function it performs.*[10]

Freud had himself recognised that dreams involve psychic 'work' and that psychoanalysis itself is a constant work in progress. Perhaps it should be no surprise that the labour and conflict that produce the 'compromise' of the dream and of the session turns out to have surprising affinities. Of course there is work and work; dreams and sessions are not all of a piece: some serve more creative, productive and communicative functions than others. Some dreams appear not to establish a liaison between the unconscious phantasy and our conscious mind, but on the contrary, to be aimed at evacuation. Certain 'day dreams' can be seen as examples of that, retreats from psychic engagement, repositories into which unwanted content is 'binned'. Other dreams, as the Swiss psychoanalyst, Jean-Michel Quinodoz, evocatively suggests, 'turn over a page', marking—and perhaps in turn bringing about—real psychic change.[11] It is also striking how patients have periods in analysis when dreams are copiously available or strikingly absent. This contemporary emphasis on the variable quality of the 'work' of the dream and of the analysis builds on Freud, who had already illuminated so many different kinds of psychic task, amongst which we find 'dream work' and 'the work of mourning'. He once defined the aim of psychoanalysis as helping the patient to love and to work. We now focus on the joint employment of patient and analyst: how does the patient collaborate, collude or come into conflict with the endeavour? How does this change—if at all—moment by moment? The analyst labours to

monitor his or her own input, perhaps to wonder how his own personal anxieties or narcissism, aggression or envy interfere, or to ask whether these qualities are projected by or into the patient. This is not to say—at least not in the tradition in which I trained—that the aim would be to communicate such self-'monitoring' to the patient in the form of a confessional—the analyst crucially remains as far as possible 'abstinent'. We aim to 'work through', recognising also, as best we can, that neither the analyst's nor the analysand's ego is master in its own house.

William Shakespeare

from *Richard III*, Act I, Scene iv
(The Duke of Clarence is interrupted in his last sleep before he is murdered)

Keeper:	Why looks your Grace so heavily to-day?
Clarence:	O, I have pass'd a miserable night,
	So full of fearful dreams, of ugly sights,
	That, as I am a Christian faithful man,
	I would not spend another such a night
	Though 'twere to buy a world of happy days—
	So full of dismal terror was the time!
Keeper:	What was your dream, my lord? I pray that you tell me.
Clarence:	Methoughts that I had broken from the Tower
	And was embark'd to cross to Burgundy;
	And in my company my brother Gloucester,
	Who from my cabin tempted me to walk
	Upon the hatches. Thence we look'd toward England,
	And cited up a thousand heavy times,
	During the wars of York and Lancaster,
	That had befall'n us. As we pac'd along
	Upon the giddy footing of the hatches,
	Methought that Gloucester stumbled, and in falling
	Struck me, that thought to stay him, overboard
	Into the tumbling billows of the main.
	O Lord, methought what pain it was to drown,
	What dreadful noise of waters in my ears,
	What sights of ugly death within my eyes!
	Methoughts I saw a thousand fearful wrecks,
	A thousand men that fishes gnaw'd upon,
	Wedges of gold, great anchors, heaps of pearl,
	Inestimable stones, unvalued jewels,
	All scatt'red in the bottom of the sea;
	Some lay in dead men's skulls, and in the holes
	Where eyes did once inhabit there were crept,
	As 'twere scorn of eyes, reflecting gems,
	That woo'd the slimy bottom of the deep
	And mock'd the dead bones that lay scatt'red by.
Keeper:	Had you such leisure in the time of death
	To gaze upon these secrets of the deep?
Clarence:	Methought I had;

1 Daniel Pick is an associate member of the British Psychoanalytical Society, professor of history at Birkbeck, University of London and an editor of *History Workshop Journal*.

2 'Transference' has been defined and elaborated in various ways, but can be taken as meaning the process by which the patient unconsciously redirects earlier feelings and wishes onto the figure of the analyst. In the transference, unconscious experiences, emotions or anxieties are attributed and repeated through the relationship with the analyst. Freud described how the patient sees in the analyst "the return, the reincarnation, of some important figure out of his childhood or past, and consequently transfers on to him feelings and reactions which undoubtedly applied to this prototype. This fact of transference soon proves to be a factor of undreamt-of importance, on the one hand an instrument of irreplaceable value and on the other hand a source of serious dangers." Counter-transference indicates the psychoanalyst's unconscious attitudes and feelings in regard to the patient. "An Outline of Psycho-Analysis", [1938], *Standard Edition of the Complete Works of Freud*, London, 1964, vol 23, pp. 174–175. For an illuminating account of changing clinical approaches, see Sara Flanders, *The Dream Discourse Today*, London, 1993.

3 Strikingly, *The Interpretation of Dreams* was a work that Freud could never leave alone, frequently revising, expanding and developing his account, in subsequent editions that also bore witness to the collaborative enterprise of analysis—material from colleagues, patients and from Freud himself, 'in process', long beyond 1900. See Ilse Grubrich-Simitis, "How Freud wrote and revised his *Interpretation of Dreams*", in *Dreams and History: The Interpretation of Dreams from Ancient Greece to Modern Psychoanalysis*, edited by Daniel Pick and Lyndal Roper, London, 2004, ch 2.

4 Žižek, Slavoj. *The Sublime Object of Ideology*, London, 1989, pp. 12–13.

5 Freud, Sigmund. "The Interpretation of Dreams" [1900], *Standard Edition of the Complete Works of Freud*, London, 1953, vol. 5, pp. 506–507n. Cf. Žižek, op cit. pp. 13.

6 *International Journal of Psychoanalysis*, 1948: 29:73-97, pp. 78.

7 *International Journal of Psychoanalysis*, 1948: 29:73-97, pp. 78.

8 See Ronald Britton and John Steiner, "Interpretation: Selected Fact or Overvalued Idea?" *International Journal of Psycho-Analysis*, 1994: 75: 1069–1078.

9 See Sebastiano Timpanaro, *The Freudian Slip*, London, 1976. Cf Perry Anderson's *A Zone of Engagement*, London, 1992, which—drawing on Timpanaro and, apparently, Karl Popper—places the psychoanalytic interpretation of dreams alongside other 'unfalsifiable' approaches that establish what they want in advance, and brook no contradiction.

10 Pontalis, JB. *Frontiers in Psychoanalysis: Between the Dream and Psychic Pain*, London, 1981, p. 29.

11 "Psychoanalysis, Dreams, History: an Interview with Hanna Segal", in *Dreams and History*, ch 12.

12 See J M Quinodoz, "Dreams that Turn Over a Page: Integration Dreams with Paradoxical Regressive Content", *International Journal of Psychoanalysis*, 1999: 80, pp. 225–238.

Roald Dahl

from *The BFG*

"Is there a dream floating around in here now?"
Sophie asked.

The BFG moved his great ears this way and that,
listening intently. He shook his head. "There is no
dream in here", he said, "except in the bottles. I has a
special place to go for catching dreams. They is not
often coming to Giant Country."

"How do you catch them?"

"The same way you is catching butteryflies", the
BFG answered. "With a net." He stood up and crossed
over to a corner of the cave where a pole was leaning
against the wall. The pole was about 30 feet long and
there was a net on the end of it. "Here is the dream-
catcher", he said, grasping the pole in one hand. "Every
morning I is going out a snitching new dreams to put in
my bottles."

"Dreams is very mystical things", the BFG said.

"Human beans is not understanding them at all.
Not even their brainiest professors is understanding
them. Has you seen enough?"

"Just this last one", Sophie said. "This one here."

She started reading:

*I has ritten a book and it is so exciting nobody can put it down. As soon as you has
red the first line you is so hooked on it you cannot stop until the last page. In all the
cities peeple is walking in the streets bumping into each other because their faces is
buried in my book and dentists is reading it and trying to fill teeths at the same time
but nobody minds because they is all reading it too in the dentist's chair. Drivers is
reading it while driving and cars is crashing all over the country. Brain surgeons is
reading it while they is operating on brains and airline pilots is reading it and going
to timbuctoo instead of london. Football players is reading it on the field because
they can't put it down and so is olimpick runners while they is running. Everybody
has to see what is going to happen next in my book and when i wake up i is still
tingling with excitement at being the greatest riter the world has ever known until
my mummy comes in and says i was looking at your english exercise book last nite
and really your spelling is atroshus so is your puntulashon.*

A Man Asleep Dreaming of Monsters
Francisco de Goya y Lucientes
1797–1798

Aquatint with etching
Wellcome Library, London

The sequence of etchings known as *Los Caprichos* occupies an important position in Goya's work.

It vividly illustrates the worlds of night and dreams. Night is shown, not just as fuel for the artistic imagination, but also as a warning against areas of society where reason no longer holds sway. Goya himself wrote: "Fantasy, abandoned by reason, produces impossible monsters; united with it, she is the mother of the arts and the origin of marvels"

Man and Mouse
Katharina Fritsch
1991–1992

Polyester, pigment, steel
Düsseldorf, Kunstsammlung
Nordrhein-Westfalen
© VG-Bild-Kunst, Bonn
Photograph: Nic Tenwiggenhorn

Man and Mouse recalls the painting
The Nightmare by Henry Fuseli.
Fritsch's sculpture reverses the
relation of the sexes: instead of the
beautiful sleeping woman it is a
man who is almost smothered by
the creature of the nightmare.

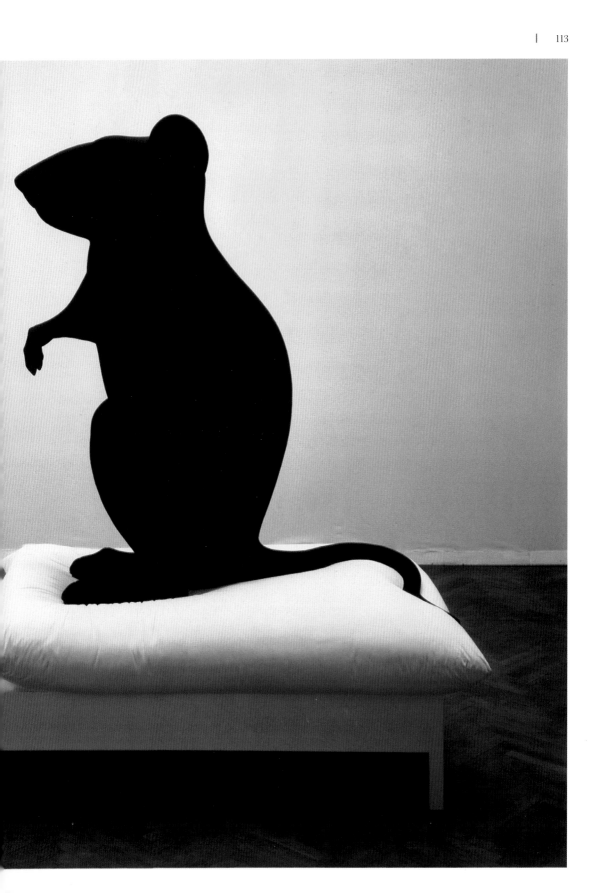

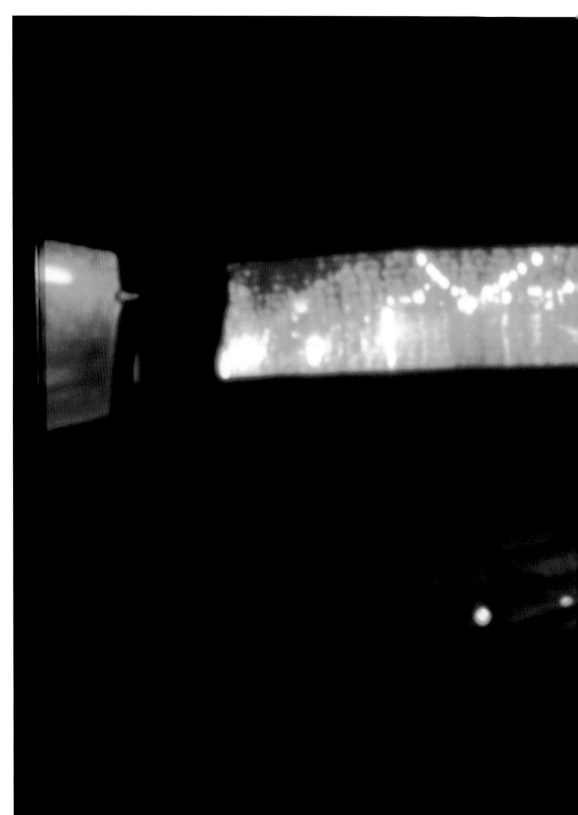

Rodney Graham
1994

DVD-Projection, 26 minutes.
Courtesy of the artist and Lisson
Gallery, London

The film is restricted to a single
camera angle. Having taken the
sleeping pill 'Halcion' in a motel,
the artist, fast asleep and clad in
pyjamas, is driven home to bed
through Vancouver on the back
seat of a car.

Images of the urban landscape
pass by the back window like the
projection of a dream. The images
of the sleeper's own dreams are
invisible to us.

Detail from
Another Day
Paul Ramírez Jonas
2001

Dream Worlds of the Modern Era:

Philosophical Dream Criticism and the Hermeneutics of Suspicion

Ralf Konersmann

Slavery is ever preceded by sleep.
Montesquieu, *L'Esprit des Lois* (On the Spirit of Laws), XIV 13

Philosophers have always been suspicious of the realities of dreams. What they were fascinated by, albeit reluctantly, was their phenomenological qualities, their regular return and what nightly submersion in sleep can tell us about states of waking and consciousness.

Philosophical dream theories favour a clear structure to problems. The theatre of dreams is beyond the boundaries of waking consciousness, itself defined by the perpetuation of conscious boundaries. This process is certainly not as natural as it seems. The self-delimitation of the consciousness is modelled on that earlier, elementary division of the world into the two parts that we experience every day: day and night, light and darkness, life on earth and the afterlife, finitude and infinity. According to Nietzsche's explanation of 'misunderstanding dreams', dreams are the absolute metaphor for, and the continuous affirmation of, the metaphysical division of the world into two distinct kinds of thing.[1] When we turn our analytical eye to this common dichotomy, we rob it of its implicitness and bring into the realm of reflection. According to Nietzsche's *On the Genealogy of Morality*, reason's claim to power stems from the banal fact of dreaming, from a natural 'dissection' of—and asymmetry in—human beings' experience of existence. As a result of our dreaming states, the world appears to us in duplicate. Dreams demonstrate that apart from the legible everyday experiences we normally have, there is this other side of life remote from our waking world. Further, this mysterious dream space is itself carved into two major experiential planes: the 'dream as a world of its own' and the 'dream about the world'.

Jean Anthelme Brillat-Savarin

from *The Physiology of Taste*
(trans G Almansi)

One night I dreamt I had found a secret way to free myself from the laws of gravity, so that my body could indifferently rise or sink since I could do either at will with equal facility. This condition seemed to me delightful. Perhaps many people have dreamt something similar; what is extraordinary is that I remember I could explain to myself with great clarity (at least so it seemed to me) the means by which I had reached this result. They seemed to me so simple that I wondered why they hadn't been found before. When I woke up, this explanatory part was completely obliterated from my mind, but the conclusion was still there. Since then, I cannot help being convinced that sooner or later a more enlightened genius will make this discovery, and just in case I put my name down.

Nothing is more intimate than the imagery of dreams. We all dream by ourselves, and from time immemorial, dreaming has been an allegory for a profound loneliness that cannot be alleviated by anything or anyone. Thinking, on the other hand, has always involved others, and if it is thinking in the Socratic tradition, it must be communicated in some sort of human community. Taking up the thinking of others, and packaging it in language as a phrase, thinking is a social activity in the Socratic school. Reason is at a distance from dreams because sleepers do not take part in a shared world where thoughts and experiences are normally exchanged. The sleeper is absent; and either they immediately forget what they have dreamt about, or they are hardly capable of putting their intense dream experiences into words. For a long time, philosophy saw its reservations confirmed by this fundamental tension between dreaming and thinking. Dreams are the reversal of the conscious realm and impose an alternate logic upon the waking world. When reason falls asleep, dreams awaken and begin their fantastical doings, flying in the face of our everyday rules and expectations. Faced with this fundamental conflict between dreams' revelatory potential—which remains to be tested—and the dream-figments' unintelligibility and remoteness from reason—which never cease to astonish us—it was philosophy's own canonical commitment to the logos that finally tipped the scales and standardised philosophy's distance to the dreaming world. From that point on the philosophical history of dream was, and could only be, a form of the hermeneutics of suspicion.

There is a short treatise on dreams in the fourteenth volume of the monumental *Encyclopédie* that was intended to unite the sum of critically tested knowledge in the mid-eighteenth century ("Rêve" —Jean-Henri Formey wrote a further article under the heading of "Songe"). After his associate, D'Alembert, withdrew in 1757, Denis Diderot took it upon himself to finish the article, writing: "The history of the dream is still little explored, yet it is important, not only in medicine, but also in metaphysics; in dreaming, we have an internal sense of ourselves, and at the same time, we are quite deluded, so that we see various things outside of us; we ourselves act, whether we want to or not; and finally, all the subjects of dreams are clearly games played by the imagination."

This short theoretical text is groundbreaking. Pursuing the ambivalences of philosophical dream criticism, it initially condemns dreams as "deluded" (*un assez grand délire*) and as "game", constitutionally falling short of reality (*plusieurs choses hors de nous*). If we conceive of dreams as the products of delusion, their formation is accompanied by something like a counter-world, a counter-reality to the palpable familiarities we know as the waking world. It is this side of dreams, its arbitrariness, which provoked first the philosophers', then Diderot's, doubts. A dream is the world over again, but repeated incorrectly. To Diderot, however, dreams are even more than this, for apart from the dubiousness of dreams, it is the manifest nature of the delusion that keeps us, as experienced dreamers, from mistaking the dream for reality and from succumbing to the dangers of confusion. Diderot neutralises these dangers by appealing to the bon sens, thus envisaging the idea of a philosophical 'history of dream' and recommending it as a reputable undertaking, a worthy project. In fact, Diderot realised his intention only a little later in his dialogues on *Le Rêve d'Alembert* (D'Alembert's Dream) during 1769, daring to present a bold mix of theoretical treatises, speculative fiction, philosophy and literature.

Diderot put the history of the dream on the philosophical agenda. Dreams' potential to fascinate arises from the fact that in the imagery of dreams, we encounter imaginary material which, having originated in us, emblematically points to the psychological material that has traversed the horizon of our waking consciousness. However distortedly, the history of the dream reflects the history of our experience of the world in its full, non-rationalised intensity—a type of experience in which, as Foucault was later to write, "existence is still its own world".

Deliberations such as these also made Diderot depart from the rigor of rationalist dream criticism. If dreams are like springs rising within us, and if we can extract from them that which, in an eminent interpretation of the phrase, "has something to do with us", then we are dealing with subjects worthy of philosophical attention.

Diderot argues according to the dissident concepts of a historical anthropology that pays scant attention to this stumbling block, and he himself admits that we must deal with the philosophical problem of dreams "whether we want to or not". Dreams are a compulsion; they get out of control and we are at their mercy. Sleep and dreams spirit us away into a nighttime world that we can no longer shape, and in abandoning ourselves to it, we are crossing the borders that define us according to classical metaphysics: the world of the psyche, the consciousness, reason. It comes as no surprise, then, that in describing this giving over, philosophers—particularly those of the Enlightenment—tended to assume the rhetoric of surrender. Dreams and sleep stand for the end of waking, the forfeiture of consciousness, the breakdown of control and the renunciation of intelligibility. The presence of dreams confirms the absence of reason.

In the course of its existence, philosophy has developed very different routines to soften the experience of the unalterable and to make it easier for individuals to deal with the forces of fate. In opposition to the idealists who (as Diderot says) counter dreams with objections and demonise them, the ancient teachings of wisdom counselled that sleep and dreams, like everything determined by fate, should be accepted as given. Experience advises one not to reject dreams, but rather to foster virtue in dealing with them. The topos of death as sleep's brother (as found in, for instance, the works of Ovid and Cicero) is a result of this acceptance procedure. A simple analogy forms the basis of this thought: as sleep and death cannot be avoided and their tertium comparationis consists in their being irrevocable, the sleeping are in some sense preparing for death. The act of abandoning oneself to sleep finds a resonance with the Socratic maxim, which states that philosophising *just is* learning to die. If extended, this analogy eventually goes beyond morals and crosses the border into religion, which holds that after our individual deaths, we shall wake up in earnest and see the everlasting light, just as we find our way back to the daylight of the waking world every morning. The dual analogy of passing into sleep/passing away and waking up/awakening helps to make the doctrines of immortality credible. But there is also a flipside to this line of thought. It not only comforts the sleeper, but also exposes him to a dramatic proximity to death, whose horrors can only be overcome by placing an unshakable trust in God. The German lyrics

Gérard de Nerval

from *Aurélia* (trans G Wagner)

I suddenly found myself in a room which formed part of my grandfather's house, only it seemed to have grown larger. The old furniture glowed with a miraculous polish, the carpets and curtains were as if new again, daylight three times more brilliant than natural day came in through the windows and the door, and in the air there was a freshness and perfume like the first warm morning of spring. Three women were working in the room and, without exactly resembling them, they stood for relatives and friends of my youth. Each seemed to have the features of several of them. Their facial contours changed like the flame of a lamp, and all the time something of one was passing to the other. Their smiles, the colour of their eyes and hair, their figures and familiar gestures, all these were exchanged as if they had lived the same life, and each was made up of all three, like those figures painters take from a number of models in order to achieve perfect beauty.

The eldest spoke to me in a vibrant, melodious voice which I recognised as having heard in my childhood, and whatever it was she said struck me as being profoundly true.

to Brahms' Lullaby translate as, "Tomorrow morning, be it God's will/ You shall wake up again"—this is the Christian description of the feeling of exposure, expressed in perhaps the most popular piece from the collection of romantic songs, *Des Knaben Wunderhorn* (The Boy's Magic Horn) from 1805.

The Dream of Reason

It was verses like this that consolidated these reactions to the isolated helplessness of sleep, and further, allowed this latent anxiety to be harnessed by a religious culture of consolation in the nineteenth century. However, decades before, these motifs had provoked the opposition of idealists and particularly Enlightenment reasoning, and therefore it makes little sense to simply shrug off rationalist dream criticism as a failed project. Dreams, as we have said earlier, are a compulsion, because it is impossible for us not to dream. After all, we do not dream, as the cliche would have it, in the way that we would see a film, as a distant viewer sitting in front of a planar surface. Instead, we are caught within our dreams, standing in the middle of their three-dimensional landscape. Often we are compliant, even willing, actors in their unfolding drama.

When in his *Laws*, Plato recommended keeping the dosage of sleep at a minimum so as not to unnecessarily hamper the activity of the mind, he gave the problem a structure that laid down an asymmetrical relationship between the waking and dreaming worlds. Philosophers (Descartes in particular) followed Plato's parameters, taking these limits as an obligatory philosophical schema. Descartes treated dreams as illusions in

Harold Wilson

I believe the greatest asset a head of state can have is the ability to get a good night's sleep.

response to questions about the difference between the dreaming and waking world, giving the threshold of consciousness problem an altogether Platonic treatment. Like opinions, sensory perceptions or delusions, dreams are obstacles down the road to truth for Descartes. Dreams depart from the realm of wisdom, morals and religion to be rearticulated as an epistemological challenge, as the touchstone of cognisance.

Descartes in no way claims that dream content is inherently false. A statement like that would be inappropriate and, above all, far too simple. The reason one cannot altogether reject dreams is precisely because its phenomena are unquestionably logical and convincing to the dreamer, as Descartes writes in his *Meditations* dreams are certainly not "simply imaginary".[2] Dreams contradict what is real and true, but at the same time, they are the duplicate of this logical realm. It is this mimetic quality inherent in the motif of reversal that makes dreams a philosophical challenge—this, and the momentum of unconditional abandonment. Sleep suspends the fear of error; it knows neither criticism nor any of its derivatives such as the power of judgement, the ability to discriminate or amazement. As dreams are manifestly beyond the reach of criticism, they allow anything to happen—especially those things we would avoid when we are awake because we judge them impermissible. The effect of dream is to make us acquiesce, to make us surrender to them and accept their volatility, just as we accept dream imagery's peculiar modes of transferral. When we dream, we do not get to the bottom of things, rather we are implicated in the extreme, fraught with a craving for affirmation which persists even in nightmares and inexorably augments our horror, we must watch helplessly as things transform, converge, change and swap meanings. As long as we are asleep, we cannot criticise our dream-figments, since we have chosen them and—in the act of choosing them—acknowledged them. In dreaming, our mentation even renounces the formation of preferences, it was the Cartesian Paul Valéry who recorded this precise observation on thought processes in the experience of dreaming: "Our thoughts come about in much the same way as accidental collisions".[3]

Descartes discriminates against dreams; he wants to marginalise
them. Dreams are to be marked off from waking life, and eventually
severed completely from it and discarded as inappropriate philosophical
material. To Descartes, therefore, it was essential to disprove the
formulaic spirit of the baroque age, which held that life was a dream.
In this context, one must always keep in mind that Calderón's comedy
La Vida es Sueño (Life is a Dream) was released just a year before
Descartes' *Discours de la Méthode* (Discourse on Method) was published
in 1637. Descartes hypothetically agrees with the characteristically
baroque hypothesis of pious unreality, but emphatically denies that the
thinking consciousness is also subordinated by this power. For I may be
dreaming and I may be misdirected, but still, simple and clear syllogism
will show that it is I myself to whom this is happening. Descartes draws
the state of "I am dreaming" into the process of self-reassurance implied
in "I am thinking" to break the power of dreams. I am never, not even in
dreams, illusions and delusions, separated from myself.[4]

"Reality is what one cannot wake up from," wrote Valéry in his
studies of dreams.[5] As convincing as this may sound, it is precisely this
awakening from reality that Descartes expected to experience when
he began to reflect. Descartes calls on us to wake up from reality, and
is thus wholly in agreement with Montesquieu, who was to explain
in *L'Esprit des Lois* (On the Spirit of Laws), published over one hundred
years later, that "slavery is ever preceded by sleep".[6] In this context of
philosophical dream logic, cognition is endowed with all the pathos
of self-liberation. It exhorts us to leave the semi-somnolence of a reality
that we accept as in a dream and to let ourselves be called to critical
thinking. When I wake up, I become conscious of the elementary nature
of my thinking and thus also of the fact that I exist. Passing into the
waking world, we do not only see what is true, but also how we came to
misconceive of it. Once we have put the dreaming world's rituals of
subordination behind us, we can comprehend who and what we really
are. Modern allegories of waking and rousing from a stupor or from
sleep rely on the overcoming of a dream-like, despotic illusory world
which, as Plato preformulated it canonically in his allegory of the cave,
obstructs our way to reality proper.

It is said that purposeful practice enabled Descartes to have only
reasonable dreams. This anecdote is a good invention—presumably his
own. A reasonable dream would be the triumph of a consciousness that
has attained full transparency, it would be the proof of its absolute
authority. But Descartes did not succeed in establishing this ideal, not
even in the field of philosophy. Over the next few generations there was
a radical change in the evaluation of dreams demonstrated, not only in
Diderot's article on dreams, but also in Rousseau's *Rêveries d'un Promeneur*

Italo Calvino

from *Invisible Cities* (trans William Weaver)

... After six days and seven nights, you arrive at Zobeide, the white city, well exposed to the moon, with streets wound about themselves as in a skein. They tell this tale of its foundation: men of various nations had an identical dream. They saw a woman running at night through an unknown city; she was seen from behind, with long hair, and she was naked. They dreamed of pursuing her. As they twisted and turned, each of them lost her. After the dream they set out in search of that city; they never found it, but they found one another; they decided to build a city like the one in the dream. In laying out the streets, each followed the course of his pursuit; at the spot where they had lost the fugitive's trail, they arranged spaces and walls differently from the dream, so she would be unable to escape again.

This was the city of Zobeide, where they settled, waiting for that scene to be repeated one night. None of them, asleep or awake, ever saw the woman again.

Solitaire (Reveries of a Solitary Walker), which he wrote just before his death. The book's title alone would have stuck in any Cartesian's craw, not to mention the author's introductory assertion that his writing would run "its course without being obstructed or forced". This self-disclosure will have been stylised, like much of Rousseau's work, but it is as radical as any reversal of paradigm ever had been. Under Rousseau's influence, dreams became the guarantors of a global wisdom that must elude reason, which is itself now suspect because it has been corrupted by the forces of illusion. Descartes was bent on breaking the power of dreams in order to strengthen the ego, evoked through cogito via the artifice of self-referentiality; Rousseau now predicted that the ego would make gains in authenticity if it were to resist the nomenclatures that had been introduced, and abandon itself to the intuitions it found in dreams.

This formed the basis of a specifically modern trust placed in dreams' power to testify; a trust which Freud and, particularly, surrealism were later to share. According to the conviction common in modernity, with its tendency to romanticise, dreams speak to us of their own accord. What they have to say—and in this context, this always means: what they can set against the voice of reason—enables us to look deeply into human subjectivity's history of pathos

Dreaming has a Share in History

Rousseau sharpened the focus on compiling a history of dream when he invoked its right to a counter-history, a claim later supported by romanticism. The human experience—so often marginalised or omitted in the traditional, consciousness-centered description of things—is

finally given a voice in the history of dream, in which Jacques Le Goff, Robert Muchembled and Peter Burke have all done seminal work.

Historians heard Diderot's appeal, but hardly any philosophers ever did. Only Walter Benjamin dared to present a philosophical history of dreams in his *Passagenwerk* (Arcades Project), which occupied his mind during the final years of his life. He summarised its agenda in a short essay, published in Neue Rundschau in 1927 and tellingly entitled "Traumkitsch" (Dream Kitsch). It says: "The history of the dream remains to be written, and opening up a perspective on this subject would mean decisively overcoming the superstitious belief in natural necessity by means of historical illumination. Dreaming has a share in history".[7]

If one conceives of these socio-historical projects as an implementation of the ingenious demand made by Diderot in calling for a historical anthropology of dreams, Benjamin, on the other hand is undertaking something completely novel. From the prehistory of dream theories— including psychoanalysis—he extracts a logic of dreams, encompassing a logic of time, which was strictly limited to formal references before his imput. As early as in the 1920s "Schemata zum Psychophysischen Problem" (Outline of the Psychophysical Problem) this succession is evident in the resolution to determine the relation between dreaming and waking "according to the theory of perception" rather than "according to the theory of knowledge".[8] Amounting to a rearrangement of the theoretical framework that is reinforced by the contrast between "natural necessity" and "historical illumination". Benjamin adhered to this reorientation of dream concepts fthroughout his career. His philosophy of history is a composite of the theory of perception, the rhythmification of epochs and the logic of dreams.

This shift in the problem has far-reaching consequences. Benjamin, whose passion for dream scenarios was legendary, discusses collective dreams as evidenced in films, and particularly, the communal nature of their reception. The audience's collective perception, he says in his famous essay, "Das Kunstwerk im Zeitalter Seiner Technischen Reproduzierbarkeit" (The Work of Art in the Age of Mechanical Reproduction), revokes Heraclitus' ancient maxim, that everyone is isolated in sleep, while the waking share the world with each other.[9] Films and, alongside them, product worlds, architecture, and above all, the nineteenth century arcades that his project is named after, lead the dreamers to one another and unite them in a collective. The collective dream is the absolute metaphor for the historical integration of the masses with awakening marking the moment of mobilisation. Even prior to the dream content's visualisation, packaging it into a

metaphor is rich in prerequisites. It replaces the ingrained logic of historical change—the logic of the ages of the world, the logic of healing, the logic of evolution—with the fragmented logic of dreams. Benjamin picks up the young Marx's consciousness-critical intuition, according to which the world has long desired the dream about a thing which it would only really possess when it became conscious of the dream.[10] He takes this model of re-acquisition and possessing the future, and translates it into the visual logic of dreams. This defines a problem which, when pursued, results in Benjamin's observation that in the rhythm of experiencing a dream, "everything—even things that seem as neutral as can be—happens to us", that it "concerns us".[11] The most drastic changes in waking life take place as if they were part of a dream; they come up like a spontaneous opportunity and depend on the eminent moment which the Pythagoreans once called the kairos. Indeed, Benjamin gives his philosophy a kairological twist by modelling it on a dream theory. As in the perception of a dream, decisive events "happen to us" in the space of historical reality; they are—as in dreams—"something that happens to us".[12] The imagery of dreams, which penetrates everything and shapes our concepts, displays historical epochs as a rapidly changing sequence of unexpected occurrences made known to the attentive tracker suddenly and immediately, in accordance with the pattern of awakening.

Dreams, one reads in the *Arcades Project*'s treasure-trove of quotations, "surreptitiously" await awakening.[13] This aspect of surreptitiousness, of stealth, of caution is important, for the "theory of awakening" revolutionises the strategic models of social change. The dialectic dream interpreter does not implement ready-made programmes, but instead acts with regard to fleeting, unforeseeable situations that occur suddenly—just the way that images in dreams materialise without being sought after. Dialecticians read the signs. As a methodological parameter to dream reading, Benjamin re-evaluates a remark by historian Jules Michelet which is set before his philosophical kairology like a motto: *chaque époque rêve la suivante*. Each era, Benjamin explains, dreams the following one and in doing so, urges it "to wake up".[14] The twofold redefinition of dreaming, its collectivisation and its historicisation, is embodied in this guideline. It is only in awakening that dreams can be comprehended as such, so that the present can recognise itself as a congenial waking world in the now-emergent anticipation of its defining images. This construction of historical times is objectified by the perception of the past in the 'dialectic image', the depiction of which Benjamin uses to complete the dream logic of chronological interdependences. The dialectic image, which abruptly overleaps the distance of historical times, is "where awakening is breached", as Benjamin wrote to Gretel Adorno in August 1935.[15]

Benjamin's exploration of historico-philosophical thresholds activates the dream as metaphor in order to extract from it a theory of modernity. In this way, Benjamin opens a new chapter in the history of the significance of dreams without discounting the reservations of philosophical tradition. On the contrary: Benjamin distanced himself decisively from romantic and surrealist transfigurations of dreams and from modern remythologisations and atavisms in which art takes religion's place. His discussion of Albert Béguin's work, *L'âme Romantique et le Rêve*, (The Romantic Soul and the Dream) which appeared in two volumes in 1937 and caused a resurgence in romantic esotericism, amounts to a list of "deficiencies".[16] The dreaming consciousness is childish—Benjamin stuck to the deeply sceptical view expounded by philosophical dream theorists, and he, too, stresses that dreams are uncritical. "Someone waking up today as Heinrich von Ofterdingen must have overslept."[17]

As an *exercice des soupçon* Paul Ricœur attempted to illustrate that the methods of psychoanalysis amounted to a hermeneutics of suspicion. According to Ricœur, Freud—in reading dream texts allegorically—applies them to something external to the dream work, while simultaneously reconstructing their earlier meaning by contrasting them with this external thing. Since one reality acts as a substitute for another in dreams, the point of reading dreams analytically lies in reversing the original reversal and thus reconstructing the original 'meaning'. In the face of the literalness of dream imagery, analytical practice unearths something hidden as the truth of the dream. This observation can be generalised. From time immemorial, prior to Freud and Benjamin, philosophical theories of dream interpretation have made use of the hermeneutics of suspicion. In their philosophical sense, dreams appear as negatives of the waking world, as reversals, as traces, as texts, as signs.

A late variation of this interpretational pattern can be found in Karl Löwith's suggestion to bear the "preconscious, subconscious and non-conscious Being" in mind when considering human knowledge —which philosophical anthropology usually gains from analysing conscious processes—and particularly, to consider dreams as properly belonging to this line of enquiry.[18] The aim here is not only to broaden anthropology's horizons, but also, for Löwith, to make clear that it is non-conscious forces such as those of dreaming and sleeping that follow us into the waking world to expand their sinister regime. Like Valéry, Freud and Benjamin, Löwith also considers the paradigms of consciousness philosophy inadequate precisely where the point of interest is the consciousness. If one accepts only the waking world as valid, one will end up not knowing even that world. Therefore, the

consciousness' self-referential path and descent to natural foundations must also be undertaken in reverse so as to trace the continuing effects of non-conscious life and the unforeseeable connectivity between ourselves and the nature of things.

Löwith's demand is spectacular in the context of the history of the consciousness, rather than the history of dreaming. In viewing the history of the consciousness as inextricably linked with the contingent worlds of dreams, this demand changes our notion of thinking itself. When we think, Löwith says in his late outline, this is hardly ever because we have deliberately decided to. Rather, we grant permission to what occurs to us and what devolves upon us. "No thought," says Löwith, "can be preconceived of". The main challenge faced by an anthropology enriched by findings in oneirology would lie in discovering the regime of dreams in the lowest layers of the consciousness.

1 Nietzsche, Friedrich. *Menschliches, Allzu Menschliches* (Human, All Too Human), I 5

2 Descartes, René. *Meditations on First Philosophy* I 6.

3 Valéry, Paul. *Cahiers* (Notebooks; notes and reflections on dreams)

4 Descartes, Rene. *Meditations on First Philosophy* II 6 and 7.

5 Valéry, Paul. *Cahiers (Notebooks).*

6 Montesquieu, Charles-Louis de Secondat. *On the Spirit of Laws*, vol 1, XIV, 13.

7 Benjamin, Walter. *Selected Writings*, Vol 2, Harvard University Press, Cambridge.

8 Benjamin, Walter. *Selected Writings*, Vol 1, Harvard University Press, Cambridge.

9 Heraclitus of Ephesus, *Fragment* 89.

10 Marx, Karl and Engels, Friedrich. *Werke*, Vol 1, Berlin 1956, pp. 346.

11 Benjamin, Walter. *The Arcades Project*, Harvard University Press, Cambridge.

12 Benjamin, Walter. *Gesammelte Schriften* (Collected Writings), Vol I 2, pp. 464.

13 Benjamin, Walter. *The Arcades Project*, Harvard University Press, Cambridge.

14 Benjamin, Walter. *Gesammelte Schriften* (Collected Writings), Vol V 1 pp. 59, vol. V 2, pp. 1236.

15 Benjamin, Walter. *Gesammelte Briefe 1910–1940* (Collected Letters), Vol 4, Frankfurt/ M 1998, pp. 688.

16 Benjamin, Walter. *Gesammelte Schriften* (Collected Writings), Vol III, pp. 557 ss.

17 Benjamin, Walter. *Selected Writings*, Vol 2, Harvard University Press.

18 Löwith, Karl. "Zur Frage einer Philosophischen Anthropologie" (On the Question of a Philosophical Anthropology) in: idem, *Sämtliche Schriften*, ed Klaus Stichweh, Vol 1, Stuttgart 1981, pp. 341.

**Levels of Productivity During
a Working Day**
From the illustrated series "Health
Care in Daily Life"
Educational literature published
by the Deutsches-Hygiene Museum
c 1927

Glass slide (reproduction)
Deutsches-Hygiene Museum,
Dresden

It was recognised early on that our
productivity varies in the course of
the day and that taking a break has
a restorative effect. According to
this graph, productive capacity is
negatively influenced by travelling
long distances to work, using
breaks in the wrong way, hard
labour, impaired health and
over-long working hours.

Another Day
Paul Ramírez Jonas
2001

Three monitors, computer-assisted
announcements
Property of the artist

The monitors show the countdown
in real time to sunrise in 90 cities
across the globe. As soon as the sun
has risen in one town it disappears
from the monitor and the next one
moves up. At any time, somewhere
on earth a new day begins and
night comes to an end.

Sunrise

Time to Sunrise

02:53:48	Tolé	04:40:48
02:55:48	Krakow	05:15:48
03:01:48	Agadez	05:20:48
03:19:48	Tibiri	05:33:48
03:21:48	Göteborg	06:06:48
03:36:48	Toledo	06:34:48
04:17:48	Fongolembi	06:36:48
04:32:48	Greenwich	06:37:48
04:38:48	Marrakush	06:39:48

Panasonic

Ron Mueck
2002

Mixed media
Berlin, private collection
Ron Mueck is represented by
Anthony d'Offay, London
Photographs: Mike Bruce, Gate
Studios, London

Cocooned in a blanket and tied
up like a parcel, the swaddled
baby appears calm and content.
Until the Enlightenment it
was thought that swaddling
babies would ensure that
they slept quietly.

Ron Mueck's super-realistic
presentation also allows for
associations with the birth
of Christ.

134 | **The Sleeper**
Nils Klinger
2003

Photographs:
Property of the artist

Nils Klingers photographs, taken
by candle light over a period of many
hours, indicate the individual
'signature' of the woman's sleep.
Her nocturnal movements are
compressed into a single take.

1 View from the foot of the bed VIII
2 View from the foot of the bed XV

Detail from
Dream Paintings
Jane Gifford
2004

The Interpretation of Dreams and the Neurosciences

Mark Solms[1]

Shortly after Freud's death, the study of dreaming from the perspective of neuroscience began in earnest. Initially, these studies yielded results that were hard to reconcile with the psychological conclusions set out in this book. The first major breakthrough came in 1953, when Aserinsky and Kleitman discovered a physiological state which occurs periodically (in 90 minute cycles) throughout sleep, and occupies approximately 25 per cent of our sleeping hours. This state is characterised, among other things, by heightened brain activation, bursts of rapid eye movement (REM), increased breathing and heart-rate, genital engorgement, and paralysis of bodily movement. It consists, in short, in a paradoxical physiological condition in which one is simultaneously highly aroused and unconscious. Not surprisingly, Aserinsky and Kleitman suspected that this REM state (as it came to be known) was the external manifestation of the subjective dream state. That suspicion was soon confirmed experimentally, by Aserinsky and Kleitman during 1955 and

Charles Baudelaire

from *A Letter to Charles Asselineau*
(trans J Romney)

My dear friend, since you like hearing about dreams, here is one which I am sure will not fail to please you. It is five o'clock in the morning, so it is still quite fresh. Of course, it is only one specimen out of a thousand that beset me, and I do not need to tell you that their utter strangeness, and the fact that they are generally quite alien to my personal pursuits and adventures, always lead me to believe that they form an almost hieroglyphic language to which I have no key.

It was two or three o'clock in the morning (in my dream), and I was walking alone in the streets. I ran into Castille, who I think had several errands to attend to, and I told him I would accompany him and take advantage of the carriage to run an errand of my own. So we took a carriage. I felt it a duty of sorts to present the madam of a large whorehouse with a book of mine, which had just come out. When I looked at the book in my hand, it turned out to be an obscene one, which explained the necessity of presenting the work to that woman. Moreover, in the back of my mind, this necessity was really a pretext, a chance to screw one of the tarts in passing—which suggests that if I hadn't had to present the book, I wouldn't have dared go into such a house.

George Steiner

from a lecture, "The Historicity of Dreams"

Anyone who has lived near animals, with his dog or his cat, knows of their dreams. Vivid, often clearly tempestuous, currents of agitation or pleasure will set in unmistakable motion the body of a sleeping dog or cat. In fact, this banal phenomenon is our most direct (our only direct?) behavioural evidence for the frequency and force of dreams. All human reports on dreams come to us via the screen of language.

Animals dream. Am I altogether in error in thinking that the philosophical and historical implications of this platitude are momentous, and that they have received remarkably little attention. For if animals dream, as they manifestly do, such 'dreams' are generated and experienced outside any linguistic matrix. Their content, their sensory dynamics, precede, are external to, any linguistic code.

Dement and Kleitman during 1957. It is now generally accepted that if someone is awakened from REM sleep and asked whether or not they have been dreaming, they will report that they were dreaming in as many as 95 per cent of such awakenings. Non-REM sleep, by contrast, yields dream reports at a rate of only five to ten per cent of awakenings.

These early discoveries generated great excitement in the neuroscientific field; for the first time it appeared to have in its grasp an objective, physical manifestation of dreaming—the most subjective of all mental states. All that remained to be done, it seemed, was to lay bare the brain mechanisms which produced this physiological state; then we would have discovered nothing less than how the brain produces dreams. Since the REM state can be demonstrated in almost all mammals, this research could also be conducted in subhuman species, which has important methodological implications, for brain mechanisms can be manipulated in animal experiments in ways that they cannot in human research.

A series of studies followed in quick succession, in which different parts of the brain were systematically removed (in cats) in order to isolate the precise structures that produced REM sleep. On this basis, Jouvet was able to report in 1962 that REM (and therefore dreaming) was produced by a small region of cells in a part of the brain stem known as the pons. This part of the nervous system is situated at a level only slightly above the spinal cord, near the nape of the neck. The higher levels of the brain, such as the cerebral hemispheres themselves, which fill out the great hollow of the human skull, did not appear to play any causal role whatever in the generation of dreaming. REM sleep occurs with monotonous regularity, throughout sleep, so long as the pons is intact —even if the great cerebral hemispheres are removed completely.

Neuroscientific research into the mechanism of REM sleep continued along these lines, using a wide variety of methods, and by 1975 a detailed picture of the anatomy and physiology of `dreaming sleep' had emerged. This picture, which is embodied in the reciprocal interaction and activation-synthesis models of McCarley and Hobson (1975, 1977) has dominated the field ever since—or at least, as we shall see, until very recently. These authoritative models proposed that REM sleep and dreaming were literally 'switched on' by a small group of cells situated deep within the pons, which excrete a chemical called acetylcholine. This chemical activates the higher parts of the brain, which are thereby prompted to generate meaningless conscious images. These meaningless images are nothing more than the higher brain making "the best of a bad job... from the noisy signals sent up from the brain stem".[2] After a few minutes of REM activity, the cholinergic activation arising from the brainstem is counteracted by another group of cells, also situated in the pons, which excrete two other chemicals: noradrenaline and serotonin. These chemicals 'switch off' the cholinergic activation, and thereby—according to the theory —the conscious experience of dreaming.

Thus all the complex mental processes that Freud elucidated were swept aside and replaced by a simple oscillatory mechanism by means of which consciousness is automatically switched on and off at approximately 90 minute intervals throughout sleep by reciprocally interacting chemicals which are excreted in an elementary part of the brain that has nothing whatever to do with complex mental functions. Even the most basic claims of Freud's theory no longer seemed tenable.

> *The primary motivating force of dreaming is not psychological but physiological since the time of occurrence and duration of dreaming sleep are quite constant suggesting a preprogrammed, neurally determined genesis. In fact, the neural mechanisms involved can now be precisely specified. If we assume that the physiological substrate of consciousness is in the forebrain, these facts (ie that REM is automatically generated by brainstem mechanisms) completely eliminate any possible contribution of ideas (or their neural substrate) to the primary driving force of the dream process.*[3]

On this basis, it seemed justifiable to conclude that the causal mechanisms underlying dreaming were "motivationally neutral, and that dream imagery was nothing more than "the best possible fit of intrinsically inchoate data produced by the auto-activated brain-mind".[4] The credibility of Freud's theory was, in short, severely strained by the first wave of data about dreaming that was obtained from 'anatomical preparations'—and the neuroscientific world (indeed the

Denis Diderot

from the *Encyclopédie* (trans C Scott)

The imagination of the waking consciousness is a civilised republic, kept in order by the voice of the magistrate; the imagination of the dreaming consciousness is the same republic, delivered up to anarchy.... Let us suppose that we see a stranger today, for the first time, at some entertainment, in such and such a place, in the company of other individuals: if in the evening our imagination recalls the image of this stranger, either involuntarily or because we will it, it will automatically take it upon itself to represent to us, simultaneously, the place of the entertainment, the seat occupied by the stranger, and the people we noticed in his immediate vicinity; and if we happen to see this same stranger somewhere else, after a year or ten years or more, depending on the power of our memory, even as we see him this whole escort of images, if I may so express it, will gravitate around him.

Such being the manner, therefore in which images are arranged in our brains, it is hardly surprising that so many bizarre combinations result; but this must be insisted upon, because it explains the outlandishness and apparent absurdity of dreams.

scientific world as a whole) reverted to the pre-psychoanalytic view that "dreams are froth".[5] However, alongside the observations just reviewed, which provided an increasingly precise and detailed picture of the neurology of REM sleep, a second body of evidence gradually began to accumulate, which led some neuroscientists to recognise that perhaps REM sleep was not the physiological equivalent of dreaming after all.[6]

The notion that dreaming is merely "an epiphenomenon of REM sleep" rested almost exclusively on the observation that arousal from the REM state yielded dream reports on 70 to 95 per cent of awakenings, whereas non-REM awakenings yielded such reports in only five to ten per cent of attempts.[7] Considering the vagaries of subjective memory (and especially memory for dreams), this is as close to a perfect correlation as one could reasonably expect. However, the sharp division between REM ('dreaming') sleep and non-REM ('non-dreaming') sleep began to fray when it was discovered that reports of complex mentation could, in fact, be elicited in as many as 50 per cent of awakenings from non-REM sleep. This became apparent when Foulkes awakened subjects from non-REM sleep and asked them "what was passing through your mind?" rather than "have you been dreaming?".[8] The resultant non-REM dream reports were more 'thought-like' (less vivid) than the REM dream reports, but this distinction held only for the statistical average. The fact remained that at least five to ten per cent of non-REM dream reports were "indistinguishable by any criterion from those obtained from post-REM awakenings".[9] These findings "do not support a dichotomic distinction between REM and NREM mentation, rather they suggest the hypothesis of the existence of continuous dream processing characterised by a variability within and between sleep stages".[10]

The non-REM dream reports could not be explained away as misremembered REM dreams, for it soon became apparent that dream reports could regularly be obtained even before the dreamer had entered the first REM phase. In fact, we now know that dream reports are obtainable from as many as 50 to 70 per cent of awakenings during the sleep onset phase—that is, in the first few minutes after falling asleep.[11] This is a far higher rate than at any other point during the non-REM cycle, and almost as high as the REM rate. Similarly, it was recently discovered that non-REM dreams appear with increasing length and frequency towards the end of sleep, during the rising morning phase of the diurnal rhythm. In other words, non-REM dreams do not appear randomly during the sleep cycle; dreaming is generated during non-REM sleep by specific non-REM mechanisms.

The only reliable difference between REM dream reports, sleep-onset reports, and certain other classes of non-REM dream report is that the REM reports are longer. In all other respects, the non-REM and REM dreams appear to be identical. This demonstrates conclusively that fully-fledged dreams can occur independently of the unique physiological state of REM sleep. Therefore, whatever the explanation may be for the strong correlation that exists between dreaming and REM sleep, it is no longer accepted that dreaming is caused exclusively by the REM state.

The presumed isomorphism between REM sleep and dreaming was further undermined by the emergence, very recently, of new and unexpected evidence regarding the brain mechanisms of dreaming. As already noted, the hypothesis that dreaming is merely an epiphenomenon of REM sleep rested on the high correlation between REM awakening and dream reports. But this does not imply that REM and dreaming share a unitary brain mechanism. In the light of the discovery that dreams regularly occur independently of REM sleep, it is certainly possible that the REM state and dreaming are controlled by independent brain mechanisms. The two mechanisms could well be situated in different parts of the brain, with the REM mechanism frequently triggering the dream mechanism. A two-stage causation of REM dreaming implies that the dream mechanism could also be stimulated into action by triggers other than the REM mechanism, which would explain why dreaming so frequently occurs outside of REM sleep.

This hypothesis, that two separate mechanisms—one for REM and one for dreaming—exist in the brain, can be easily tested by a standard neurological research method known as clinico-anatomical correlation. This is the classical method for testing such hypotheses: the parts of the

brain that obliterate REM sleep are removed and the investigator observes whether or not dreaming still occurs; then the parts of the brain that obliterate dreaming are removed and the investigator observes whether or not REM still occurs. If the two effects dissociate, then they are caused by different brain mechanisms. If they are affected simultaneously by damage to a single brain structure, then they are served by a unitary mechanism.

It is known that destruction of parts of the pons (and nowhere else) leads to a cessation of REM sleep in lower mammals.[12] But such experiments cannot, of course, be performed on humans—the only species that is in a position to tell us whether or not destruction of those parts of the brain leads simultaneously to a cessation of dreaming. Fortunately (for science) the relevant brain structures are occasionally destroyed in human cases by naturally occurring damage, due to spontaneous illness or traumatic injury to the brain. 26 such cases have been reported in the neurological literature, with damage to the pons which resulted in a total or near-total loss of REM sleep.[13] Surprisingly, the elimination of REM in these cases was accompanied by reported loss of dreaming in only one of the 26 patients.[14] In the other 25 cases, the investigators either could not establish this correlation or they did not consider it. By contrast, in all the other cases ever published in the neuroscientific literature in which damage to the brain did result in a reported loss of dreaming (a total of 110 patients), a completely different part of the brain was damaged and the pons was spared completely.[15] Moreover, it has been proven that REM sleep is completely preserved in these cases, despite their loss of dreaming.[16] This dissociation between cessation of REM and cessation of dreaming seriously undermines the doctrine that the REM state is the physiological equivalent of the dream state.

The parts of the brain that are crucial for dreaming and those that are crucial for REM sleep are now thought to be wholly distinct, both anatomically and functionally. The parts of the brain that are crucial for REM are in the pons, which is located in the brainstem, near the nape of the neck. The parts of the brain that are crucial for dreaming, by contrast, are situated exclusively in the higher parts of the brain, in two specific locations within the cerebral hemispheres themselves.

Robert Louis Stevenson

from *Treasure Island*

**Many's the long night I've dreamed of cheese—
toasted mostly.**

The first of these locations is in the deep white matter of the frontal lobes of the brain, just above the eyes.[17] This part of the frontal lobes contains a large fibre-pathway which transmits a chemical called dopamine from the middle of the brain to the higher parts of the brain. Damage to this pathway renders dreaming impossible, but it leaves the REM cycle completely unaffected.[18] This suggests that dreaming is generated by a different mechanism than the one that generates REM sleep—a conclusion which is strongly supported by the observation that chemical stimulation of this dopamine pathway (with drugs like L-DOPA) leads to a massive increase in the frequency and vividness of dreams without it having any effect on the frequency and intensity of REM sleep.[19] Likewise, excessively frequent and vivid dreaming which is caused by dopamine stimulants can be stopped by drugs (like anti-psychotics) which block the transmission of dopamine in this pathway.[20] In short, dreaming can be switched 'on' and 'off' by a neurochemical pathway which has nothing to do with the REM oscillator in the pons.

What, then, is the function of this higher brain pathway that is so crucial for the generation of dreams? Its main function is to "instigate goal-seeking behaviours and an organism's appetitive interactions with the world".[21] That is, to motivate the subject to seek out and engage with external objects which can satisfy its inner biological needs. These are precisely the functions that Freud attributed to the 'libidinal drive'—the primary instigator of dreams—in his 1900a theory. Accordingly, it is of considerable interest to note that damage to this pathway causes cessation of dreaming in conjunction with a massive reduction in motivated behaviour.[22] In view of the close association between dreams and certain forms of insanity, it is also interesting to note that surgical damage to this pathway (which was the primary target of the prefrontal leucotomies of the 1950s and 60s) leads to a reduction in some symptoms of psychotic illness, together with a cessation of dreaming.[23] Whatever it is that prevented leucotomised patients from maintaining their psychiatric symptoms also prevented them from generating dreams.

Don DeLillo

from *White Noise*

I woke in the grip of a death sweat. Defenseless against my own racking fears. A pause at the center of my being. I lacked the will and physical strength to get out of bed and move through the dark house, clutching walls and stair rails. To feel my way, reinhabit my body, re-enter the world. Sweat trickled down my ribs. The digital reading on the clock-radio was 3:51. Always odd numbers at times like this. What does it mean? Is death odd-numbered? Are there life-enhancing numbers, other numbers charged with menace? Babette murmured in her sleep and I moved close, breathing her heat.

Finally I slept ...

Daniil Kharms

"The Dream", from *Incidences*
(trans Neil Cornwell)

Kalugin fell asleep and had a dream that he was sitting in some bushes and a policeman was walking past the bushes.

Kalugin woke up, scratched his mouth and went to sleep again and had another dream that he was walking past some bushes and that a policeman had hidden in the bushes and was sitting there.

Kalugin woke up, put a newspaper under his head, so as not to wet the pillow with his dribblings, and went to sleep again; and again he had a dream that he was sitting in some bushes and a policeman was walking past the bushes.

Kalugin woke up, changed the newspaper, lay down and went to sleep again. He fell asleep and had another dream that he was walking past some bushes and a policeman was sitting in the bushes.

At this point Kalugin woke up and decided not to sleep any more, but he immediately fell asleep and had a dream that he was sitting behind a policeman and some bushes were walking past.

Kalugin let out a yell and tossed about in bed but couldn't wake up.

Kalugin slept straight through for four days and four nights and on the fifth day he awoke so emaciated that he had to tie his boots to his feet with string, so that they didn't fall off. In the bakery where Kalugin always bought wheaten bread, they didn't recognise him and handed him a half-rye loaf.

And a sanitary commission which was going round the apartments, on catching sight of Kalugin, decided that he was unsanitary and no use for anything and instructed the janitors to throw Kalugin out with the rubbish.

Kalugin was folded in two and thrown out as rubbish.

In short, the current neuroscientific evidence gives us every reason to take seriously the radical hypothesis—first set out in Freud's book a hundred years ago—that dreams are motivated phenomena, driven by our wishes. Although it is true that the (cholinergic) mechanism which generates the REM state is 'motivationally neutral', this cannot be said of the (dopaminergic) mechanism which generates the dream state. In fact, the latter mechanism is the appetitive(ie libidinal) 'command system' of the brain.[24] As stated, it now appears that REM only causes dreaming via the intermediary of this motivational mechanism. Moreover, REM is just one of the many different triggers which are capable of activating this mechanism. A variety of other triggers, which act independently of REM, have exactly the same effect. Sleep-onset dreams and late morning dreams are two examples of this kind, where dreams induced by L-DOPA (and various stimulant drugs) are further examples.

Of special interest in this regard is the fact that recurring, stereotyped nightmares can be induced by seizures which occur during sleep.[25] We know from Penfield's work exactly where in the brain these seizures begin, namely, in the temporal limbic system—which subserves emotional and

memory functions, and is situated in the higher forebrain, richly interconnected with the frontal lobe dopamine pathway discussed above.[26] Moreover, we know that such seizures usually occur during non-REM sleep.[27] The fact that nightmares can be 'switched on' by mechanisms in the higher parts of the brain which have nothing to do with the pons and nothing to do with REM sleep is further evidence that dreaming and REM are generated by separate and independent brain mechanisms.

It is surely no accident that what all of these different mechanisms capable of triggering dreams have in common is the fact that they create a state of arousal during sleep. This lends support to another of the cardinal hypotheses that Freud put forward in this book, namely the hypothesis that dreams are a response to something which disturbs sleep.[28] But it appears that the arousal stimuli enumerated above only trigger dreaming if and when they activate the final common motivational pathway within the frontal lobes of the brain, for it is only when this pathway is removed (rather than the arousal triggers themselves, including REM) that dreaming becomes impossible. This relationship between the various arousal triggers and the dream-onset mechanism itself is reminiscent of Freud's famous analogy: dreaming only occurs if the stimulus which acts as the 'entrepreneur' of the dream attracts the support of a 'capitalist'—an unconscious libidinal urge, which alone has the power to generate dreaming.[29]

Thus, Freud's major inferences from psychological evidence regarding both the causes and the function of dreaming are at least compatible with, and even indirectly supported by, current neuroscientific knowledge. Does the same apply to the mechanism of dreaming? Our current neuroscientific understanding of the mechanism of dreaming revolves centrally around the concept of regression. The prevailing view is that imagery of all kinds (including dream imagery) is generated by "projecting information backward in the system'".[30] Accordingly, dreaming is conceptualised as "internally generated images which are fed backwards into the cortex as if they were coming from the outside".[31] This conception of dream imagery is based on wide-ranging neurophysiological and neuropsychological research into numerous aspects of visual processing. However the regressive nature of dream processing has recently been demonstrated directly in clinical neurological cases.[32]

In order to illustrate this point it is necessary to remind the reader that loss of dreaming due to neurological damage is associated with damage in two brain locations. The first of these is the white fibre pathway of the frontal lobes that we have considered already. The second location is a

portion of the grey cortex at the back of the brain (just behind and above the ears) called the occipitotemporo-parietal junction. This part of the brain performs the highest levels of processing of perceptual information, and it is essential for:

> *The conversion of concrete perception into abstract thinking, which always proceeds*
> *in the form of internal schemes, and for the memorising of organised experience or,*
> *in other words, not only for the perception of information but also*
> *for its storage.*

The fact that dreaming ceases completely with damage to this part of the brain suggests that these functions (the conversion of concrete perceptions into abstract thoughts and memories) like the motivational functions performed by the frontal lobe pathway discussed previously, are fundamental to the whole process of dreaming. However, if the theory that dream imagery is generated by a process which reverses the normal sequence of events in perceptual processing is correct, then we may expect that in dreams abstract thoughts and memories are converted into concrete perceptions. This is exactly what Freud had in mind when he wrote that "in regression the fabric of the dream-thoughts is resolved into its raw material". This inference is supported empirically by the observation that dreaming as a whole stops completely with damage at the highest level of the perceptual systems (in the region of the occipito-temporo-junction), whereas only specific aspects of dream imagery are affected by damage at lower levels of the visual system, closer to the perceptual periphery (in the region of the occipital lobe).[33] This implies that the contribution of the higher levels precedes that of the lower levels. When there is damage at the higher levels, dreaming is blocked completely, whereas damage at the lower levels merely subtracts something from the terminal stage of the dream process. This is the opposite of what happens in waking perception, which is obliterated entirely by damage at the lowest levels of the system. In other words, dreaming reverses the normal sequence of perceptual events.

The available neuroscientific evidence, therefore, is compatible with Freud's conception of where and how the dream process is initiated (ie, by an arousing stimulus which activates the emotional and motivational systems) and of where and how it terminates (ie by abstract thinking in the memory systems which is projected backwards in the form of concrete images onto the perceptual systems).

In fact, it is now possible to actually see where this neural activity is distributed in the dreaming brain. Modern neuroradiological methods produce pictures of the pattern of metabolic activity in the living brain while it is actually performing a particular function, and in the case of dreaming these images clearly show how the brain's energic 'cathexis' (as Freud called it) is concentrated

within the anatomical areas discussed above—namely, the (frontal and limbic) parts of the brain concerned with arousal, emotion, memory and motivation on the one hand, and the parts (at the back of the brain) concerned with abstract thinking and visual perception, on the other hand.[34]

These radiological pictures also reveal something about what happens in between the initial and terminal ends of the dream process. The most striking feature of the dreaming brain in this respect is the fact that a region of the brain known as the dorsolateral frontal convexity is completely inactive during dreams. This is striking, because this part of the brain, which is inactive during dreams, is one of the most active of all brain areas during waking mental activity. If one compares the pictures of the waking brain with those of the dreaming brain, one literally sees the truth of Fechner's 1889 assertion to the effect that "the scene of action of dreams is different from that of waking ideational life".[35] Whereas in waking ideational life the 'scene of action' is concentrated in the dorsolateral region at the front of the brain—"the upper end of the motor system—the gateway from thought to action".[36] In dreams it is concentrated in the occipito-temporo-parietal region at the back of the brain—on the memory and perceptual systems. In short, in dreams the 'scene' shifts from the motor end of the apparatus to the perceptual end.[37] This reflects the fact that whereas in waking life the normal course of mental events is directed toward action, in dreams this path is unavailable. The 'gateway' to the motor systems (the dorsolateral frontal convexity of the brain) is blocked in dreams, as are the motor output channels (the alpha motor neurons of the spinal cord).[38] Thus both the intention to act and the ability to act are blocked during sleep, and it seems reasonable to infer (as did Freud) that this block is the immediate cause of the dream process assuming a regressive path, away from the motor systems of the brain, toward the perceptual systems.[39]

Finally, due to relative inactivation during sleep of crucial parts of the reflective systems in the frontal parts of the limbic brain, the imagined dream scene is uncritically accepted, and the dreamer mistakes the internally generated scene for a real perception. Damage to these reflective systems (which evidently are not entirely inactive during sleep) results in a curious state of almost constant dreaming during sleep and an inability to distinguish between thoughts and real events during waking life.[40] This provides further evidence of a continuous thought process occurring during sleep, which is converted into dreaming under various physiological conditions, of which REM sleep is just one among many.

The picture of the dreaming brain that emerges from recent neuroscientific research may therefore be summarised as follows: the process of dreaming is initiated by an arousal stimulus. If this stimulus is

sufficiently intense or persistent to activate the motivational mechanisms of the brain (or if it attracts the interest of these mechanisms for some other reason) the dream process proper begins. The functioning of the motivational systems of the brain is normally channelled toward goal-directed action, but access to the motor systems is blocked during sleep, and the purposive action that would be the normal outcome of motivated interest is thereby rendered impossible during sleep. As a result (and quite possibly in order to protect sleep) the process of activation assumes a regressive course. This appears to involve a two-stage process. First, the higher parts of the perceptual systems (which serve memory and abstract thinking) are activated; then the lower parts (which serve concrete imagery) are activated. As a result of this regressive process, the dreamer does not actually engage in motivated activity during sleep, but rather imagines himself to be doing so. Due to inactivation during sleep of the reflective systems in the frontal part of the limbic brain, the imagined scene is uncritically accepted, and the dreamer mistakes it for a real perception.

There is a great deal about the dreaming brain that we still do not understand. It is also evident that we have not yet discovered the neurological correlates of some crucial components of the 'dream-work' as Freud understood it. The function of 'censorship' is the most glaring example of this kind. However, we are beginning to understand something about the neurological correlates of that function, and we know at least that the structures which are most likely to be implicated are indeed highly active during dreaming sleep.[41]

Hopefully it is apparent to the reader from this brief overview that the picture of the dreaming brain which has begun to emerge from the most recent neuroscientific research is broadly compatible with the psychological theory that Freud advanced. In fact, aspects of Freud's account of the dreaming mind are so consistent with the currently available neuroscientific data that I personally think we would be well advised to use Freud's model as a guide for the next phase of our neuroscientific investigations. Unlike the research effort of the past few decades, the next stage in our investigation into brain mechanisms of dreaming (if it is to succeed) must take as its starting point the new perspective we have gained on the role of REM sleep. REM sleep, which has hitherto diverted our attention away from the neuropsychological mechanisms of dreaming, should simply be added to the various 'somatic sources' of dreams that Freud discussed. The major focus of our future research efforts should then be directed toward elucidating the brain correlates of the mechanisms of the dream-work proper.

We shall feel no surprise at the over-estimation of the part played in forming dreams by stimuli which do not arise from mental life. Not only are they easy to discover and even open to experimental confirmation; but the somatic view of the origin of dreams is completely in line with the prevailing

trend of thought in psychiatry today. It is true that the dominance of the brain over the organism is asserted with apparent confidence. Nevertheless, anything that might indicate that mental life is in any way independent of demonstrable organic changes or that its manifestations are in any way spontaneous alarms the modern psychiatrist, as though a recognition of such things would inevitably bring back the days of the philosophy of nature, and the metaphysical view of the nature of mind. The suspicions of the psychiatrists have put the mind, as it were, under tutelage, and they now insist that none of its impulses shall be allowed to suggest that it has any means of its own. This behaviour of theirs only shows how little trust they really have in the validity of a causal connection between the somatic and the mental. Even when investigation shows the primary exciting cause of a phenomenon is psychical, deeper research will one day trace the path further and discover an organic basis for the mental event. But if at the moment we cannot see beyond the mental, that is no reason for denying its existence.[42]

1 Professor Mark Solms Academic Department of Neurosurgery St. Bartholomew's & Royal London School of Medicine London E1 1BB.

2 Hobson and McCarley, 1977, p. 1347.

3 Hobson and McCarley, 1977, pp. 1346, 1338.

4 Hobson, 1988, p. 204.

5 Freud, 1900a, p. 133.

6 Solms (in press).

7 Hobson et al, 1998, p. R12.

8 Foulkes, 1962.

9 Hobson, 1988, p. 143.

10 Cavellero et al, 1992, p. 563.

11 Foulkes and Vogel, 1965; Foulkes et al, 1966; Vogel et al, 1972.

12 Jones, 1979.

13 Adey et al, 1968; Chase et al, 1968; Cummings and Greenberg, 1977; Feldman, 1971; Lavie et al, 1984; Mark and and Dyken, 1976; Osorio and Daroff, 1980 (for bibliographic details see Solms, 1997).

14 Feldman, 1971.

15 Basso, Bisiach and Luzzatti, 1980; Boyle and Nielsen, 1954; Epstein, 1979; Epstein and Simmons, 1983; Ettlinger, Warrington and Zangwill, 1957; Farah, Levine and Calviano, 1988; Farrell, 1969; Gloning and Sternbach, 1953; Grünstein, 1924; Habib and Sirigu, 1987; Humphrey and Zangwill, 1951; Lyman, Kwan and Chao, 1938; Michel and Sieroff, 1981; Moss, 1972; Müller, 1892; Neal, 1988; Nielsen, 1955; Peña-Casanova et al, 1985; Piehler, 1950; Ritchie, 1959; Solms, 1997; Wapner, Judd and Gardner, 1978; Wilbrand, 1887, 1892 (for bibliographic details see Solms, 1997).

16 Benson and Greenberg, 1969; Brown, 1972; Cathala et al, 1983; Efron, 1968; Jus et al, 1973; Kerr, Foulkes and Jurkovic, 1978; Michel and Sieroff, 1981; Murri et al, 1985 (for bibliographic details see Solms, 1997).

17 Solms, 1997.

18 Jus et al, 1973.

19 Klawans et al, 1978; Scharf et al, 1978; Hartmann et al, 1980; Nausieda et al, 1982.

20 Sacks, 1985, 1990, 1991.

21 Panksepp, 985, p. 273.

22 Solms, 1997.

23 Frank, 1946, 1950; Partridge, 1953; Schindler, 1953.

24 Panksepp, 1985, 1998.

25 De Sanctis, 1896; Thomayer, 1897; Clarke, 1915; Kardiner, 1932; Naville and Brantmay, 1935; Rodin et al, 1955; Ostow, 1954; Epstein and Ervin, 1956; Snyder, 1958; Epstein, 1964; Epstein and Hill, 1966; Epstein, 1967; Boller et al, 1975; Epstein, 1979; Epstein and Freeman, 1981; Solms, 1997 (for bibliographic details see Solms, 1997).

26 Penfield was able to artificially generate the recurring nightmare scenes by directly stimulating the seizure focus in the temporal lobe (Penfield, 1938; Penfield and Erickson, 1941; Penfield and Rasmussen, 1955).

27 Janz, 1974; Kellaway and Frost, 1983.

28 Solms (1995, 1997) provides limited empirical evidence to support the hypothesis that dreams protect sleep: patients who lose the ability to dream due to brain damage report more disturbed sleep than brain damaged patients with intact dreaming.

29 1900a, p. 561.

30 Kosslyn, 1994, p. 75

31 Zeki, 1993, p. 326.

32 Solms, 1997.

33 Charcot, 1883; Adler, 1944, 1950; Brain, 1950, 1954; Macrae and Trolle, 1956; Tzavaras, 1967; Kerr et al, 1978; Botez et al, 1985; Sacks and Wasserman, 1987; Solms, 1997 (for bibliographic details see Solms, 1997).

34 Braun et al, 1997, 1998; Franck et al, 1987; Franzini, 1992; Heiss et al, 1985; Hong et al, 1995; Madsen, 1993; Madsen and Vorstrup, 1991; Madsen et al, 1991a, 1991b; Maquet et al, 1990, 1996 (for bibliographic details see Braun et al, 1997).

35 cf Freud, 1900a, p. 536.

36 Solms, 1997, p. 223.

37 It is of utmost interest to note that the major inhibitory systems of the forebrain are concentrated at its motor end, just as they were in Freud's (1900a) diagrammatic representation of the mental apparatus.

38 Braun et al, 1997, 1998; Solms, 1997, Pompeiano, 1979.

39 Solms, 1997.

40 Whitty and Lewin, 1957; Lugaresi et al, 1986; Gallassi et al, 1992; Morris et al, 1992; Sacks, 1995; Solms, 1997 (for bibliographic details see Solms, 1997).

41 Solms, 1998 Braun et al, 1997, 1998.

42 Freud 1900a, pp. 41–42.

Christina Rossetti

"My Dream"

Hear now a curious dream I dreamed last night,
Each word whereof is weighed and sifted truth.

I stood beside Euphrates while it swelled
Like overflowing Jordan in its youth:
It waxed and coloured sensibly to sight;
Till out of myriad pregnant waves there welled
Young crocodiles, a gaunt blunt-featured crew,
Fresh-hatched perhaps and daubed with birthday dew.
The rest if I should tell, I fear my friend
My closest friend, would deem the facts untrue;
And therefore it were wisely left untold;
Yet if you will, why, hear it to the end.

Each crocodile was girt with massive gold
And polished stones that with their wearers grew:
But one there was who waxed beyond the rest,
Wore kinglier girdle and a kingly crown,
Whilst crowns and orbs and sceptres starred his breast.
All gleamed compact and green with scale on scale,
But special burnishment adorned his mail
And special terror weighed upon his frown;
His punier brethren quaked before his tail,
Broad as a rafter, potent as a flail.

So he grew lord and master of his kin:
But who shall tell the tale of all their woes?
An execrable appetite arose,
He battened on them, crunched, and sucked them in.
He knew no law, he feared no binding law,
But ground them with inexorable jaw:
The luscious fat distilled upon his chin,
Exuded from his nostrils and his eyes,
While still like hungry death he fed his maw;
Till every minor crocodile being dead
And buried too, himself gorged to the full,
He slept with breath oppressed and unstrung claw.
Oh marvel passing strange which next I saw:
In sleep he dwindled to the common size,
And all the empire faded from his coat.
Then from far off a wingèd vessel came,
Swift as a swallow, subtle as a flame:
I know not what it bore of freight or host,
But white it was as an avenging ghost.
It levelled strong Euphrates in its course;
Supreme yet weightless as an idle mote
It seemed to tame the waters without force
Till not a murmur swelled or billow beat:
Lo, as the purple shadow swept the sands,
The prudent crocodile rose on his feet
And shed appropriate tears and wrung his hands.

What can it mean? you ask. I answer not
For meaning, but myself must echo, What?
And tell it as I saw it on the spot.

References

Aserinsky, E and Kleitman, N. "Regularly Occurring Periods of Eye Motility and Concurrent Phenomena During Sleep", *Science*, 1953, 118:273.

Aserinsky, E and Kleitman, N. "Two Types of Ocular Motility During Sleep" *The Journal of Applied Physiology*, 1955, 8:1.

Braun, A et al. "Regional Cerebral Blood Flow Throughout the Sleep-Wake Cycle", *Brain*, 1997, 120:1173.

Braun, A et al. "Dissociated Pattern of Activity in Visual Cortices and their Projections During Human Rapid Eye Movement Sleep", *Science*, 1998, 279:91.

Cavallero, C et al. "Slow Wave Sleep Dreaming" *Sleep*, 1992,15:562.

Dement, W and Kleitman, N. "Cyclic Variations in EEG During Sleep and Their Relation to Eye Movements, Body Mobility and Dreaming", *Electroencephalography and Clinical Neurophysiology*, 1957a, 9:673.

Dement, W and Kleitman, N. "The Relation of Eye Movements During Sleep to Dream Activity: an objective method for the study of dreaming", *The Journal of Experimental Psychology*, 1957b, 53:89.

Fechner, G. (1889): *Elemente der Psychophysik*. Breitkopf & Härtel, Leipzig

Feldman, M. "Physiological Observations in a Chronic Case of 'Locked-in' Syndrome", *Neurology*,1971, 21:459.

Foulkes, D. "Dream Reports from Different Stages of Sleep", *Journal of Abnormal Social Psychology*, 1962, 65:14.

Foulkes, D, Spear P and Symonds J. "Individual Differences in Mental Activity at Sleep Onset", *Journal of Abnormal Psychology*, 1966, 71:280.

Foulkes, D and Vogel G. "Mental Activity at Sleep Onset" *Journal of Abnormal Social Psychology*, 1965, 70:231.

Frank, J. "Clinical Survey and Results of 200 Cases of Prefrontal Leucotomy", *Journal of Mental Science*, 1946, 92:497.

Frank, J. "Some Aspects of Lobotomy (prefrontal leucotomy) Under Psychoanalytic Scrutiny", *Psychiatry*,1950, 13:35.

Freud, S. *The Interpretation of Dreams in SE 4/5* J Strachey, (ed) Hogarth: London, 1900a.

Hartmann, E, Russ, D, Oldfield M, Falke, R and Skoff, B. "Dream Content: Effects of L-DOPA", *The Journal of Sleep Research*, 1980, 9:153.

Hobson, J. *The Dreaming Brain*. Basic Books: New York, 1988.

Hobson, J, Stickgold R, Pace-Schott, E. "The Neuropsychology of REM Sleep Dreaming", *NeuroReport*,1998, 9:R1.

Hobson, J and McCarley, R. "The Brain as a Dream-State Generator", *American Journal Psychiatry*,1977, 134:1335.

Janz, D. "Epilepsy and the Sleep-Waking Cycle", *Handbook of Clinical Neurology*, 15, P Vinken and G Bruyn, (eds) Elsevier: Amsterdam, 1974, pp. 457–490.

Jones, B. "Elimination of Paradoxical Sleep by Lesions of the Pontine Gigantocellular Tegmental Field in the Cat", *Neuroscience Letters*, 1979, 13:285.

Jouvet, M. "Recherches sur les Structures Nerveuses et les Mecanismes Responsables des Differentes Phases du Sommeil Physiologique", *Archives Italiennes de Biologie*, 1962, 153:125.

Jus, A et al. "Studies on Dream Recall in Chronic Schizophrenic Patients After Prefrontal Lobotomy", *Biological Psychiatry*, 1973, 6:275.

Kellaway, P and Frost, J. "Biorythmic Modulation of Epileptic Events",

Recent Advances in Epilepsy 1, T Pedley and B Meldrum (eds) Churchill Livingstone: Edinburgh and London, 1983, pp.139–154.

Klawans, H, Moskowitz, C, Lupton M and Scharf B. "Induction of Dreams by Levodopa". *Harefuah*,1978, 45:57.

Kondo, T, Antrobus, J, and Fein, G. "Later REM Activation and Sleep Mentation", *The Journal of Sleep Research*, 1989,18:147.

Kosslyn, S. *Image and Brain*, MIT Press: Cambridge, 1994.

Luria, A. *The Working Brain*, Penguin: Harmondsworth, 1973.

McCarley, R and Hobson, J A. "Neuronal Excitability Modulation over the Sleep Cycle: a Structural and Mathematical Model", *Science*,1975, 189:58.

McCarley, R and Hobson, J A. "The Neurobiological Origins of Psychoanalytic Dream Theory", *The American Journal of Psychiatry*, 1977, 134:1211.

Nausieda, P et al. "Sleep Disruption in the Course of Chronic Levodopa Therapy: an early feature of the levodopa psychosis", *Clinical Neuropharmacology*, 1982, 5:183.

Panksepp, J. "Mood Changes" in *Handbook of Clinical Neurology 45*, P Vinken, G, Bruyn, H, Klawans (eds) Elsevier: Amsterdam, pp. 271–285.

Panksepp, J. *Affective Neuroscience: The Foundations of Human and Animal Emotions*, Oxford University Press: New York, 1998.

Partridge, M. *Pre-Frontal Leucotomy: A Survey of 300 Cases Personally Followed for 1Ω-3 Years*, Blackwell: Oxford,1950.

Penfield, W. "The Cerebral Cortex in Man I: the Cerebral Cortex and Consciousness", *Archive of Neurological Psychiatry*, 1938, 40:417.

Penfield, W and Erickson, T. *Epilepsy and Cerebral Localisation*, Thomas: Springfield,1941.

Penfield, W and Rasmussen, T. *The Cerebral Cortex of Man*, MacMillan: New York, 1979

Pompeiano, O. "Cholinergic Activation of Reticular and Vestibular Mechanisms Controlling Posture and Eye Movements" *The Reticular Formation Revisited*, J A Hobson and M Brazier (eds), Raven: New York, 1979, pp. 473–572.

Sacks, O. *The Man Who Mistook His Wife for a Hat*, Duckworth: London, 1985.

Sacks, O. *Awakenings*, HarperCollins: New York, 1990.

Sacks, O. "Neurological Dreams", *MD*, 29 February 1991.

Scharf, B, Moscovitz, C, Lupton, C and Klawans, H. "Dream Phenomena Induced by Chronic Levodopa Therapy", *Journal of Neural Transmission*, 1978, 43:143.

Schindler, R. "Das Traumleben der Leukotomierten", *Wien. Zeitschr. Nervenheil.* 1953, 6:330.

Solms, M. "New Findings on the Neurological Organisation of Dreaming Implications for Psychoanalysis", *Psychoanalysis Quarterly*, 1995, 64:43–67.

Solms, M. "The Neuropsychology of Dreams" *Erlbaum*, Mahwah: New Jersey, 1997.

Solms, M. Psychoanalytische Beobachtungen an vier Patienten mit ventromesialen Frontalhirnläsionen. Psyche. 1998, 52: 919–62.

Solms, M. "Dreaming and REM Sleep are Controlled by Different Brain Mechanisms", *Behavioural Brain Science* (in press).

Vogel, G, Barrowclough, B and Giesler, D. "Limited Discriminability of REM and Sleep Onset Reports and its Psychiatric Implications", *Archives of General Psychiatry* 1972 pp. 26:449.

Zeki, S. *A Vision of the Brain*, Blackwell: Oxford, 1993.

The Nightmare
Martin Joachim Schmidt after
Henry Fuseli
After 1781

Stipple engraving
Wellcome Library, London

The painting *The Nightmare* by
Henry Fuseli, shows the 'dark side'
of Romanticism. An incubus, or
demon, squats on the sleeping
woman, while a horse, suggestive
of wild, unfettered nature, pokes
its head through a curtain. The
insinuation of sexual desire helped
the painting to become one of the
most famous and frequently
referred to works of art in Europe.

A pink church, sinking.
In the foreground entrance
into a hollow tree.
Dream of 17 May.

Encountering ghosts in
Bali, with paper blood.
Dream of 3 July.

Oil on MDF
Property of the artist

For several years Jane Gifford
has concerned herself exclusively with
dreams and ways of recording and
preserving them. The *Dream Paintings*
of 2004 record her dreams during a
period of 144 days in images and texts.

A tree bridging a stream,
wooden boat, figures.
Dream of 15 November.

In a cafe in a bathrobe with
an architectural model,
possibly waiting for Keith Y.
Dream of 15 October.

Untitled
Beate Frommelt
2006

Inkjet on hand-made paper
Property of the artist

The Danish theologian and
natural scientist Niels Stensen
believed that the brain contracted
in sleep, assisting the cerebellum
to regenerate itself. The artist
Beate Frommelt has interpreted
these early assumptions about
the nature of sleep in sequences
of drawings.

Detail from
Night Work in Germany
Maurice Weiss
2006–2007

No Sleep–Only Dreams

A L Kennedy

I don't sleep, not the way I used to. Which is supposed to be a part of getting older, isn't it? Eventually, we're all meant to linger in retirement homes and bungalows, singing old songs, staring while our televisions scream and napping maybe four hours in a night. I used to think there were biological reasons for this, but now I know it's to do with our minds, our souls, our damage. When we sleep we cannot help what we will see, what our hearts will speak to us when we are undefended: the dead and the lost will return, or shimmer beyond our reach and we will be a little more broken by this each time. We grow afraid of sleeping. Its punishments are kinder than its gifts: in sleep we are children again, we are every kind of impossibility, almost infinite and whole—just before the morning wakes us and takes us away again, back into life. They say that sleeping is a kind of death, but surely it's waking that limits us, hurts us, kills us.

Of course, as a writer I have trained myself to dream awake. Or rather, I have trained myself to remain childish, to do what any healthy five-year-old might for entertainment, but to make it my living—to imagine realities other than this. In the last 20 years I have spent weeks, months, years, in worlds that have no existence and before that, when I was a reader only, there were more years of escape into happy nowheres and before that, into private day dreams. I have no idea how long I have ever had to bear being myself in my own existence. Too long for my taste, but probably much less than the majority of adults. On the one hand, this is a mercy. I have sat in my study and been everywhere I want to go, been everyone I want to be. On the other hand, this is a prison. I burn out the years with friends and loves who have never been, with different shades of nothingness and have to fight to make a place for flesh and blood.

Because the writer's life is not just writing, not any more, not only those long, plain, necessarily solitary hours. Now there are the readings, residencies, trips, the blur of hotel rooms and airports and sanitised strangers that helps to earn a wage—friends made in Australia who live in Canada, made in America who live in Ireland, made anywhere but home and worn thin with distance —affections across time zones, online, on the run. And as the dates flicker —a day gained here, lost there—as the time shifts become commonplace, the languages interchangeable, sleep fades. Writers become used to being onstage and presentable at midnight, darkness at noon, dinner at breakfast time and bread with another name, another taste, another way of being made. We jolt in and out of the heightened nightmares of strange beds and violent daylight.

My jetlag is permanent, because I encourage it, always have. I never did enjoy sleeping—the quiet time when my parents weren't fighting, when I didn't have to go to school or take part in any organised activities—the night was mine. And as soon as I could write the night was the time for writing, letting the mind open to catch what it might and then scratching it down on to paper. Naturally, I can't always keep to my personal schedule: there are deadlines to meet and phone calls to be made within office hours and meetings to hold in the convenient and reasonable space between sunrise and sunset, so my working life bounces between my time zone and everyone else's. But this only helps me, makes those sudden escapes into darkness more tender and disturbing: the shock of tiredness and then the conscious subsiding and the subconscious bleeding through, dreams rising to be expressed. Working on the end of books, the hungry final lash of their demands, more and more, that I simply do not sleep until they are done—so two or three days will sweat by as the last pages are shaken out through me and then finally I'm left alone to bath and go to bed, lie in the unusual peace of exhaustion.

And night people seek night people: comics, story-tellers, the ones who'll stay up all night to keep the words winding out around each other, who'll keep on until they build something out of nothing, worlds out of breath. I spend more and more time in comedy clubs, work more and more in comedy clubs, because of the times when we all become night people, when the words take on their own momentum and sing us alive and make dreams that delight and disturb while we are safe in the company of others, when we no longer read the books or write them, when we *are* the books. And suddenly this is dreaming with a friend, with a room full of friends, taking the dark and turning it hot, this is all the conversations that you wait for—the ones where you build the bridges as you run across them, the ones where your voice is in another's mind, their mouth is in your voice, where someone else can lift your thoughts and then outstrip them and you are both beyond yourselves and the words can touch anything, anything—even the beautiful horror of being. We hope,

Jonathan Coe

from *The House of Sleep*

"I told you,' said Terry. 'I don't sleep".
"Everybody sleeps, Mr Worth. I hope you're not going to try to persuade me, now or at any other time, that you have had no sleep at all for the last twelve years."
"I've had very little,' said Terry. 'Although, as you say, perhaps I've been imagining it. Or dreaming it, or something. Do people dream that they've had no sleep?"
"Certainly. That happens all the time."

Maurice Sendak

from *Where the Wild Things Are*

**That very night in Max's room a forest grew
and grew—
and grew until his ceiling hung with vines
and the walls became the world all around
and an ocean tumbled by with a private boat for Max
and he sailed off through night and day
and in and out of weeks
and almost over a year
to where the wild things are.**

we pray, we love, we have sex, we steal, we pretend, we are frightened so very often, we are ridiculous and we must die—what can we keep between us and this much terror, if not our created dreams?

So I look for the dreams and the dreamers and I go to sleep less and less. But this dreaming, is it simply escapist, a denial of responsibility? I'm not sure. Sometimes there is a need for escape, a responsibility to save oneself. How many writers, artists, myself included, have made their first work a means of escape? There you are, trapped in a tiny, smothering town and unemployable. Or perhaps it's the office that stifles, the marriage, the family, the system of accidents that has bound itself in against you. The fact is, you don't fit. Your interests lie in peculiar places and your sensitivities are badly adjusted. It isn't that you think you are better than other people—the ones who go to work at the jobs they hate, the ones who agree to live each day in a way that leaves them minorly or majorly harmed, robbed—you just can't see why that kind of constant violation should be tolerated by anyone. The marriages of compromise, the agreement to be numb, partly asleep and without dream—even the threat of this makes it difficult to breathe. So you make your own work—odd, long hours, an unaccustomed internal effort, an exposure to new fears—and you continue it and know it to be a kind of freedom. It is more than work, it is a part of your personality and the dream you open and walk into takes you apart from the grey life and into a coloured one—it is a fantasy, but it keeps you alive. And then slowly, slowly, your dream of escape, that corner of your mind that shelters you, becomes a real escape. You can earn a living doing what you like, being who you like and you can stay alive, awake. You can be useful without too much compromise, you can find joy quite regularly, you can leave the tiny, smothering town if you wish to, you can be where you might be happy and meet people with the same sensitivities, interests and fears. Your dream-rehearsed reality gave you itself.

No Sleep–Only Dreams

Not that the grey life is without its dreams—a dreamless half-life would be too hard to tolerate. But its dreams are provided at the users' expense, a packaged product expressly designed for the tired, for the partially awake. These are dreams of proximity to fame, little bursts of fake emotion centred on celebrity romance, or sporting events, or endearing animals. These are dreams of uncomplicated sexuality, instantaneous access and fulfilment, all darker fantasies encouraged for the sake of maintaining interest in something perpetually unattainable. These are dreams of bravery, war without dishonour, death without pain, chaos without injustice, bodies without blood. These are dreams of inexhaustible desire, the lovely descent into a helpless addict's greed, the necessity of acquisition, the defence of possession. These are dreams of the dangerous stranger, the other religion, the foreign custom, the evil and all-pervading threat—the dreams that keep you cowed and satisfied with your lot, proud of your circumscribed self, your ignorance, your wilfully unexamined fear. These are dreams designed to offer no escape.

Sometimes people wake, of course—they fall in love their own way, with their own joy, they grow and they build new dreams. Their pain surprises them, their wrongs frighten them, their compassion changes them and they build new dreams. They long for escape, a different world, and they build new dreams. But this is not encouraged. The more successful dreams will be appropriated and repackaged, defused. The individual, private, precious ones will be distrusted and identified as dangerous, wrong.

Having escaped a tiny, smothering town I now live in a tiny, smothering country. My society, my economy, no longer functions without doing harm —I might say, undreamed-of harm. But we could dream it, if we chose to, we could seek to avoid it, if we chose to. Meanwhile, the mass dreams we are sold

John Keats

"To Sleep"

O soft embalmer of the still midnight,
Shutting with careful fingers and benign
Our gloom-pleas'd eyes, embower'd from the light,
Enshaded in forgetfulness divine:
O soothest Sleep! if so it please thee, close
In midst of this thine hymn my willing eyes,
Or wait the amen ere thy poppy throws
Around my bed its lulling charities.
Then save me, or the passed day will shine
Upon my pillow, breeding many woes;
Save me from curious conscience, that still lords
Its strength for darkness, burrowing like a mole;
Turn the key deftly in the oiled wards,
And seal the hushed casket of my soul.

Gustave Flaubert

from *The Dictionary of Accepted Ideas*
(trans M Polizzotti)

Sleep: Too much of it thickens the blood.

have become other countries' nightmares and our nightmares have chased us further and further from our freedom, from our truth. We drink more than we can manage, we spend more than we have, we eat more than we need to and we find no comfort. We confuse soap-stars with their characters, we telephone chat shows for company, vote for game show contestants to feel we have a say, need guidance when we buy electrical goods in case our choice will not make us attractive to others and ourselves. Our adults read children's fiction and play with toys, maybe looking for a way back to the time when they were entirely alive and owned their dreams, made make-believe. Never really awake, never really asleep, never rested, never strong, we are an unhappy, unhealthy people.

I began by saying that I feared my dreams and I do. Within them the imagination can do anything—unleash all of my darkness, all of my light. But to live without truly dreaming is to be mad and to die. It is right for me to be in awe of something larger than myself, beyond my control, a giver and withholder of gifts too beautiful to contemplate, too terrible to touch. It is perfectly fitting for me to be cautious, respectful as I approach the source of my vocation and let it take me in. My dreaming is like anyone else's—terrible and wonderful, but without it I would be nothing. Without the light of our dreams, how can we combat the dark? Without that light, how can we find ourselves, renew ourselves, grow in the safety of an imagined womb?

Without that light I cannot see the reality of my life when I return to it, or the ghosts of possible change within it. Without my regular exposure to these moments within a kind of infinite, how I cannot be ready for whatever my death will mean—either a greater dream or a greater nothingness. Without that snap of closure whenever I wake, that parting, I cannot learn to love what I love when I have it, to embrace the full shape of my life, to treasure it, hold it lightly as something I must lose, as passing as a breath, a thought.

No Sleep–Only Dreams

In her photographic work
Catherine Yass concerns herself
not with the depiction of dreams
but with their atmosphere.
Superimposing two pictures
taken shortly after one another
and manipulating the colours
suggests the ephemeral and
surreal nature of dreams. The
motif of the image can suddenly
appear and disappear in the
light box, like the recollection
of a dream.

Sleep (Eye)
Catherine Yass
2006

Ilfochrome transparency, light box
© Catherine Yass
Courtesy of Alison Jacques
Gallery, London.

Sleep (Mask)
Catherine Yass
2006

Ilfochrome transparency, light box
© Catherine Yass
Courtesy of Alison Jacques
Gallery, London

Night Work in Germany
Maurice Weiss
2006–2007

Photographs:
Berlin, Ostkreuz/Photographer's agency

Dr Sabine Bresslerauf
Paediatrician
Hanover, 01:56 am

Frank Fettke.
Cleaner for the company PEHA
GmbH.
Neuruppin, 00:18 am

The Sleeper
Nils Klinger
2003

Photograph:
Property of the artist

View from the foot of the bed I

Authors

Ken Arnold
Head of Public Programmes at the Wellcome Trust, London.

Tamara Fischmann, Dr rer med
Psychologist and psychoanalyst at the Sigmund Freud Institute,
Frankfurt am Main.

Manfred Geier, Prof Dr phil
Linguist and philosopher at the Leibniz University, Hannover
and a freelance writer living in Hamburg.

AL Kennedy
Author, filmmaker and playwright living in Glasgow.

Ralf Konersmann, Prof PhD
Director of the Institute of Philosophy at the Christian Albrechts
University, Kiel.

Daniel Pick
Psychoanalyst and Professor at the School of History, Classics
and Archaeology, Birkbeck, University of London.

Mark Solms, Prof Dr med
Neuroscientist and psychoanalyst at Groote Schuur Hospital,
Cape Town and at the Royal School of Medicine, London.

Klaus Vogel
Director of the Deutsches Hygiene-Museum, Dresden.

Ullrich Wagner, Dr med
Neurophysiologist at the University of Lübeck.

Jürgen Zulley, Prof Dr med.
Head of the Centre for Sleep Medicine at the University of Regensburg.

Quotes and Excerpts Acknowledgements

Excerpt from *The Mezzanine* by Nicholson Baker reprinted by permission from the author and Granta Books.

Excerpt from *The Famished Road* by Ben Okri reprinted by permission of The Marsh Agency Ltd.

Excerpt from *The Unconsoled* by Kazuo Ishiguro, copyright 1995 by Kazuo Ishiguro, reprinted by permission of Alfred A Knopf, a division of Random House, Inc

Excerpt from *Music and Silence* by Rose Tremain, published by Chatto & Windus is reprinted by permission of The Random House Group Ltd.

Excerpt from *The House of Sleep* by Jonathan Coe, copyright 1997 by Jonathon Coe, reprinted by permission of Alfred A Knopf, a division of Random House, Inc.

Excerpt from *A Wild Sheep Chase* by Haruki Marakami, published by Harvill, is reprinted by permission of The Random House Group Ltd.

Excerpt from *Do Androids Dream of Electric Sheep?* by Phillip K Dick is reprinted by permission of the author and the author's agent, Scovil Chichak Galen Literary Agency, Inc.

Excerpt from *Invisible Cities* by Italo Calvino, copyright 1972 by Guilio Einaudi editore spa, English translation by William Weaver copyright 1974 Harcourt, Inc, reprinted by permission of Harcourt, Inc.

Excerpt from "The Historicity of Dreams" by George Steiner from *No Passion Spent: Essays 1978–1995* by George Steiner (Yale University Press, 1996). Reprinted by permission of Georges Borchardt, Inc, on behalf of the author.

Excerpt from *Where the Wild Things Are* by Maurice Sendak, published by Bodley Head, is reprinted by permission of The Random House Group Ltd.

10a Acton Street
London WC1X 9NG
T. +44 (0)20 7613 1922
F. +44 (0)20 7613 1944
E. info@blackdogonline.com
W. www.blackdogonline.com

Designed by Draught Associates and bdp
Edited by Nadine Käthe Monem
Assistants: Henry Fleet, Nikos Kotsopoulos

British Library Cataloguing-in-Publication Data.
A CIP record for this book is available from the British Library.
ISBN 978 1 906155 05 6

Wellcome Collection is a visitor destination from the Wellcome Trust that explores
the connections between medicine, life and art. Its exhibitions and accompanying
events aim to challenge and inspire visitors to consider issues of science, health and
human identity through the ages. The venue also houses the Wellcome Library,
Europe's leading resource for the study of history of medicine, and is located at
183 Euston Road, London NW1. See www.wellcomecollection.org

Black Dog Publishing, London, UK is an environmentally responsible company.
Sleeping and Dreaming is printed on AcondaVerd Silk, an FSC certified coated paper.

architecture art design
fashion history photography
theory and things

www.blackdogonline.com